Special Problems

LIFE LIBRARY OF PHOTOGRAPHY

Special Problems

BY THE EDITORS OF TIME-LIFE BOOKS

TIME-LIFE BOOKS, NEW YORK

ON THE COVER: The brutal heat of the desert and the bitter cold of a snowstorm are but two of the special problems photographers must face. Allen Dutton's picture of the desert near Yuma, Arizona, was taken in December. But he had to shoot it at dawn to avoid the fierce sun that bakes the land even in winter. The picture of snow on the door of a shed by Minor White was shot after a five-day blizzard in upper New York State. The 10° temperature made the metal of the camera so cold White had to shift it from hand to hand, even though he was wearing gloves.

Contents

The Harsh Environment **1** 9

Obstacles of Setting **2** 43

Problems of the Professional **3** 69

Mechanical Failure **4** 99

Photographing Action **5** 125

The Assigned Problem **6** 155

The Deliberate Mistake **7** 173

Bibliography and Acknowledgments 205
Picture Credits 206
Index 207

TIME-LIFE BOOKS

────────────

Founder: Henry R. Luce 1898-1967

Editor-in-Chief: Hedley Donovan
Chairman of the Board: Andrew Heiskell
President: James R. Shepley
Chairman, Executive Committee:
James A. Linen
Editorial Director: Louis Banks

Vice Chairman: Roy E. Larsen

────────────

Editor: Jerry Korn
Executive Editor: A. B. C. Whipple
Planning Director: Oliver E. Allen
Text Director: Martin Mann
Art Director: Sheldon Cotler
Chief of Research: Beatrice T. Dobie
Director of Photography: Melvin L. Scott
Associate Planning Director: Byron Dobell
Assistant Text Directors:
Ogden Tanner, Diana Hirsh
Assistant Art Director:
Arnold C. Holeywell
Assistant Chief of Research:
Martha T. Goolrick

Publisher: Joan D. Manley
General Manager: John D. McSweeney
Business Manager:
John Steven Maxwell
Sales Director: Carl G. Jaeger
Promotion Director:
Paul R. Stewart
Public Relations Director:
Nicholas Benton

LIFE LIBRARY OF PHOTOGRAPHY
Series Editor: Richard L. Williams

Editorial Staff for
Special Problems:
Editor: Robert G. Mason
Picture Editor: Patricia Maye
Text Editor: Jay Brennan
Designer: Raymond Ripper
Assistant Designer:
Herbert H. Quarmby
Staff Writers: George Constable,
Paula Pierce, Suzanne Seixas,
John von Hartz, Bryce S. Walker
Chief Researcher: Peggy Bushong
Researchers: Sondra Albert,
Kathleen Brandes, Malabar Brodeur,
Monica O. Horne, Myra Mangan,
Shirley Miller, Kathryn Ritchell
Art Assistant: Patricia Byrne

Editorial Production
Production Editor: Douglas B. Graham
Quality Director: Robert L. Young
Assistant: James J. Cox
Copy Staff: Rosalind Stubenberg,
Barbara Fairchild, Ruth Kelton,
Florence Keith
Picture Department: Dolores A. Littles,
Catherine Ireys

LIFE STAFF PHOTOGRAPHERS
Carlo Bavagnoli
Ralph Crane
John Dominis
Bill Eppridge
Henry Groskinsky
Yale Joel
John Loengard
Michael Mauney
Leonard McCombe
Vernon Merritt III
Ralph Morse
Carl Mydans
John Olson
Bill Ray
Co Rentmeester
Michael Rougier
John Shearer
George Silk
Grey Villet
Stan Wayman

Director of Photography:
Richard Pollard
TIME-LIFE Photo Lab Chief:
George Karas
Deputy Chief: Herbert Orth

Portions of this book were written by LIFE photographer Mark Kauffman as well as by Photo Equipment Supervisor Al Schneider. Valuable assistance also was contributed by these individuals and departments of Time Inc.: Editorial Production, Norman Airey, Margaret T. Fischer; Library, Peter Draz; Picture Collection, Doris O'Neil; TIME-LIFE News Service, Murray J. Gart; Correspondents Maria Vincenza Aloisi (Paris), Margot Hapgood (London), Elisabeth Kraemer (Bonn) and Ann Natanson (Rome).

The special problems of photography —and there are many—seldom discourage the serious photographer. On the contrary, these very problems stimulate his interest, their goad prodding him to some of his finest pictures. They excite him to stretch and extend the outer limits of his knowledge, and in the process acquire a better understanding of the full capacities of his camera, equipment and ingenuity.

The shot considered a routine assignment by an experienced professional may be a hazardous adventure for the beginner. But for photographers of every rank, certain special problems are universal. One is the all-pervasive power of nature's extremes; under the lash of a freezing rain or the heat of a summer sun, simply preserving film, lenses and camera—let alone getting a good picture—is a severe test. More exotic perils include the dust, fire and explosions of an erupting volcano or an insidious fungus that will spread over equipment in the damp tropics.

Mechanical failures that ruin a picture can be avoided by foresighted testing. But far more common are the problems of setting—reflections, obstacles, distances that get in the way of clear and dramatic pictures; yet all can be got around by the proper technique. There is one classic problem that has plagued and intrigued photographers since the development of the camera and can never finally be solved: how to convey a sense of action in the utterly motionless medium of still photography. But the attempts to resolve this problem lead to pictures that communicate the idea of action to the viewer.

These problems, while not those of every photographer, are basic to the entire photographic experience. To understand their traps is to begin to realize ways to avoid them. Or to make use of them. For some of the most exciting pictures are those that are deliberately shot the wrong way—and turn problems into advantages.

The Editors

The Harsh Environment 1

Perils of Heat and Cold, Dust and Dampness 12

The Challenge of Nature at Its Worst 26
A Volcano's Spectacular Hell-Fire 28
The Damp of Sea Air 30
Dust and Rain in the Tropics 32
The Spray of Pounding Surf 35
Dazzling Light, Frigid Cold at the Poles 36
Exploiting Antarctica's Brilliance 38
Antidotes for Sub-Zero Wind and Snow 40
Perils of the "White-Out" 42

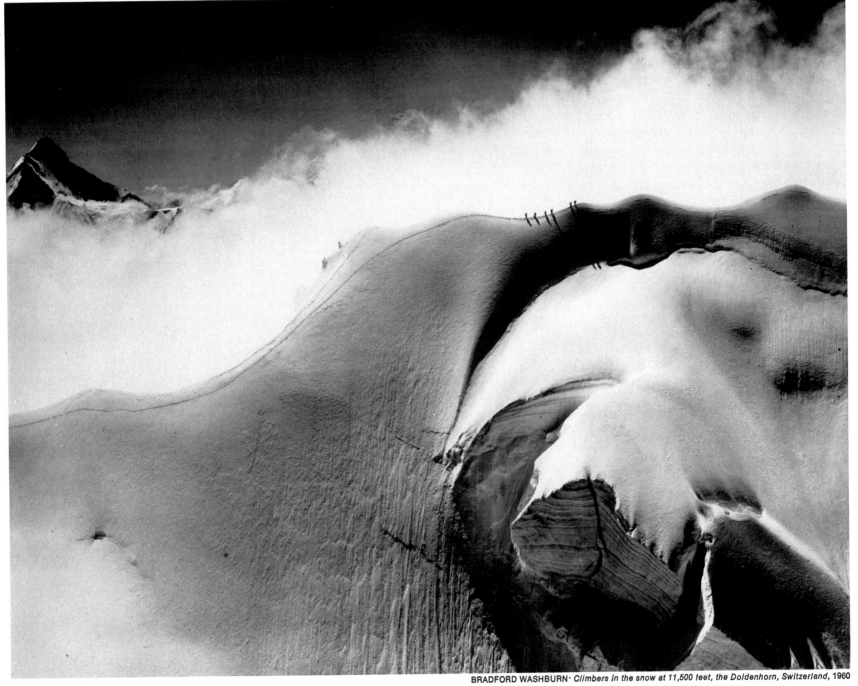

BRADFORD WASHBURN· *Climbers in the snow at 11,500 feet, the Doldenhorn, Switzerland, 1960*

11

Perils of Heat and Cold, Dust and Dampness

In many ancient cultures, weather was thought to depend on the moods of the gods—and rather irascible gods at that. Fei Lien, the Chinese deity of wind, had a dragon's body and a powerful set of lungs that could blow up a typhoon in an instant. The Norsemen placed the blame for thunder and rain on Thor, a muscular redhead who wore an iron glove and wielded a red-hot hammer. Such notions may seem outmoded, but photographers in particular might be forgiven for continuing to suspect the gods of weather of occasional malevolence. For nature itself is often the culprit when pictures fail to come out. It is not the only source of trouble, of course. Setting and lighting pose their own problems, action is difficult to convey in a still picture, equipment goes on the fritz—and the photographer makes mistakes of his own. Yet the photographic obstacles presented by the natural environment are in many ways the trickiest to surmount.

Heat, humidity, rain, snow and cold all jeopardize photographic materials and equipment. Dust, sand and salt spray also bring their share of troubles, and even the unusual lighting conditions of a summertime beach or a snow-clad mountain can play hob with exposure calculations. The harm caused by environmental extremes may be immediately obvious. If the camera shutter does not work, the film-advance mechanism jams or the film snaps, the trouble is announced at once. But more often it is impossible to learn that something went wrong until later, when developed film turns out to be ruined or the effects of camera corrosion begin to show up.

In an era when people travel widely and routinely chronicle their journeys with their cameras, an understanding of the depredations of nature has become essential. As might be expected, the types of problems vary with the climate. Troubles encountered in California's Mojave Desert differ greatly from those that bedevil the photographer in Florida's Everglades. And the difficulties of the Massachusetts seacoast scarcely resemble those of the Colorado ski slopes. Yet none of the problems are insurmountable, and often they can be solved in very simple ways.

Heat is one of the most prevalent sources of photographic miseries. At the beach, in the desert, and in practically any locale where the sun's rays are intense, the camera's lens can be harmed if it is not kept sufficiently cool. When the air is 90°F.—a level that is still reasonably comfortable if the humidity remains low—direct sunshine may cause the dark, heat-absorbing body of a camera to rise to 120° or more. A camera that is stored in the glove compartment or trunk of a car may be even worse off, for temperatures there sometimes go as high as 150°.

Whenever the temperature of a camera exceeds 110°, trouble is possible —and sometimes it is disastrous. The lubricants in the camera can thin so

much they run and gum up the delicate leaves that set the size of the aperture in the lens diaphragm. The cement that holds the glass elements of a lens together can soften and permit the elements to separate. And above 120°, bubbles could form in the optical cement, requiring expensive repairs.

To avoid such catastrophes on clear, hot days, keep equipment in the shade as much as possible. A leather case will go a long way toward shielding the camera and lenses from the sun's heat (professional photographers often carry their equipment in sturdy aluminum cases that reflect sunlight). However, a good protective device is also one of the simplest: a plastic picnic hamper, the inexpensive kind sold in hardware stores to keep food and drink hot or cold. Such hampers (page 19) offer satisfactory insulation from the sun's rays because their rigid plastic material is filled with air bubbles. They are also fairly strong and very light in weight.

Even these fine insulators have their limits, and the interior will heat up if the hamper is out in the sun for a long time, particularly after it has been

Despite the climate, Ralph Crane chose an outdoor setting for his portrait of Sheik Shakbut bin Sultan, ruler of Abu Dhabi, a small, parched sheikdom on the Persian Gulf, where temperatures routinely exceed 120°F. At the sheik's side is a $36,400, solid-gold model of an offshore oil derrick. It was presented by a grateful consortium of businessmen to whom Shakbut had granted an oil concession.

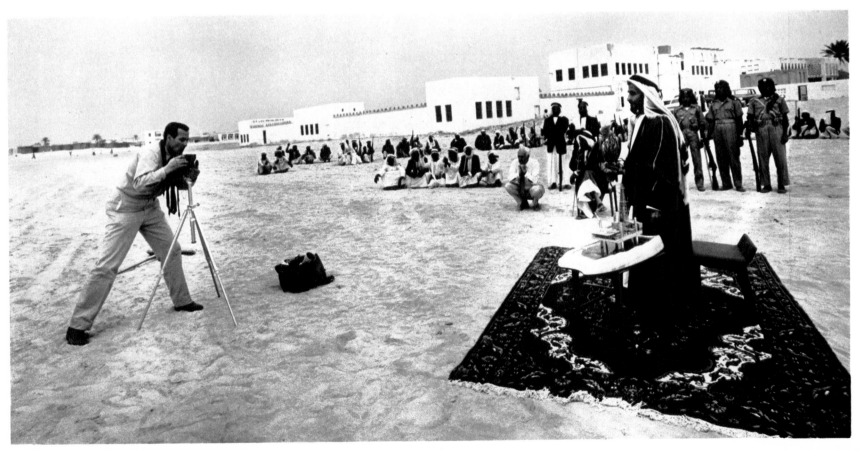

opened once or twice. One easy way to keep the temperature down under such circumstances is to keep a moistened towel on the hamper. LIFE photographer Ralph Crane chose another trick when he did a story on the oil-rich—and blazingly hot—kingdom of Abu Dhabi in 1963 *(preceding page):* each morning he placed a jarful of ice cubes in the Styrofoam hamper that he used to store his film and equipment.

An air-conditioned car is, of course, a great asset in hot climates—although, in rare instances, trouble may arise when equipment, cool from air-conditioned storage, is taken out into the broiling sun. The sudden heat starts all parts of the camera expanding, but since glass and metal expand at different rates, a lens may jam and make focusing impossible. LIFE photographer Henry Groskinsky ran into another sort of difficulty with air conditioning several summers ago when he was shooting pictures of houses in Houston, Texas, using large-format 4 x 5 and 5 x 7 cameras. He loaded the sheets of cut film into their holders while he was inside an air-conditioned house, then went outdoors to get some exterior shots. His mistake did not become evident until he developed the film and discovered that all his pictures were blurred. The cool film, subjected to a sudden rise in temperature, expanded so rapidly it buckled in the holders, throwing much of the image out of focus. This mishap could have been avoided by giving the film and holders time to warm slowly to the temperature of the surrounding air. (Such extreme buckling is much less likely with small-sized 35mm film.)

When high humidity is combined with heat, the problems worsen. In the swamps of Georgia or the bayous of Louisiana, the hostile alliance of these factors is at an extreme, yet a spell of muggy summer weather in Washington, D.C., may be troublesome too. The prime victim of hot, humid climates is film, especially after it has been unwrapped. Although modern film is very reliable and stable compared to that produced only a few decades ago, it still must be classed as a perishable product. This is hardly surprising, considering its make-up of organic gelatin (akin to gelatin foods used for desserts) and sensitive, microscopically small silver halide crystals that are easily triggered into changing their chemical form.

The combination of heat and humidity harms film in a number of ways. It can soften the gelatin so that developing solutions penetrate the emulsion at different rates when the film is processed. As a result, black-and-white pictures may seem unevenly exposed. Color pictures may appear washed out. And if color film's separate emulsion layers, which control the balance of color, are affected to different degrees, as is often the case in extremely humid tropical climates, pictures may have a reddish, bluish or greenish cast. In addition, extreme heat and humidity may act on the silver halide crystals

just as light does, producing the unwanted overall exposure called fog. These types of damage can be inflicted either before or after the film has been exposed—although they do not show up until it is developed.

In hot, damp climates, film may also fall victim to fungus (sometimes called mildew or mold). Microscopic fungus spores are everywhere in the air, and given a suitably humid environment, they rapidly multiply on the film surface because its gelatin serves as food. After five or six weeks, they will produce visible splotches or cobweblike filaments on the emulsion. If the growth has not proceeded too far, the fungus can be removed from black-and-white film with special film-cleaning preparations, but color pictures may be hopelessly damaged, for the fungus releases substances that affect the color dyes. Fungus also attracts insects and bacteria that display a similarly voracious appetite for the gelatin. And over a period of three to six months, fungus can even grow on the lens, impairing light transmission and reducing the clarity of pictures.

Still another potential difficulty arises from the moisture-absorbing properties of film. In hot, damp weather the gelatin sops up humidity like a sponge, and when it becomes sufficiently swollen with moisture, the film may stick together in its cassette or on the take-up spool. If the photographer attempts to advance or rewind it, the emulsion side of the film may rip right off the film base, thoroughly ruining the pictures.

In any hot climate where the relative humidity remains above 60 per cent, film should be kept cool and (most important of all) dry, in order to avert loss of sensitivity, attacks by fungus and moisture absorption. One sound practice is to store the film in a refrigerator until it is to be used. However, this precaution will come to naught if the moisture-proof wrapping is removed the moment that the film is taken out of the refrigerator, for water droplets may be condensed out of the humid air by the chilled emulsion, causing spotting on the film. To prevent such condensation, the film should be left in its foil wrapping overnight so that it can warm up to the temperature of the surrounding air. In any case, it is best, in tropical climates, to load a camera during the daytime because the relative humidity is higher at night, making moisture condensation more likely then, even on film that is only slightly cooler than the air around it.

A second sound precaution is to keep film inside the camera for no more than a day or two so that it cannot swell up with moisture and stick together. This is particularly necessary on any extended field trip in a humid climate. For example, LIFE photographer Stan Wayman even went to the trouble of removing the film from his cameras every night when he was doing a story on fishing in Florida (overleaf); he qualifies as an expert on the problems of damp environments, for he grew up on a small farm in the Everglades. But

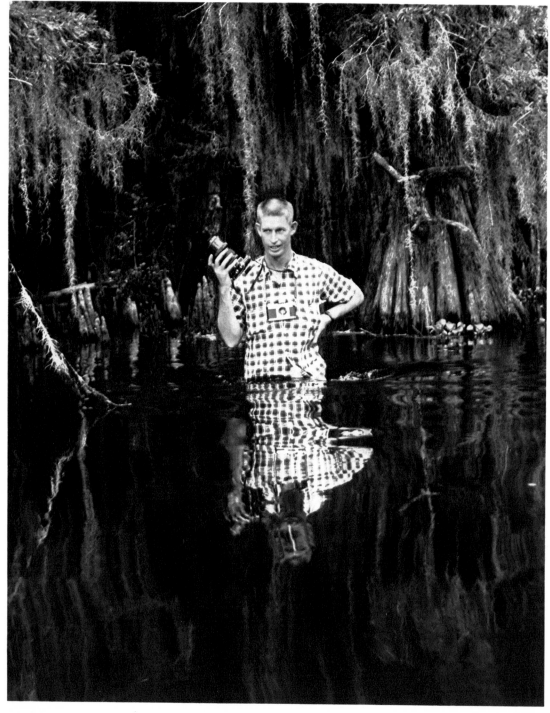

Hip-deep in a Florida waterway known as Fisheating Creek, Stan Wayman prepares to photograph an angler fly-casting for black bass. A specialist in outdoor subjects, Wayman has covered activities ranging from walrus hunts in the Bering Sea to scuba diving in Micronesia.

when an exposed roll of color film is removed from the camera outdoors, it should not be resealed in its original container until the photographer has reached some dry sanctuary, lest the humid outdoor air be locked up inside the can along with the film.

For travelers who will spend only a few days in a hot, damp climate, a convenient way to dry out exposed rolls of film—and keep them dry—is to place them in a suitcase containing freshly ironed clothes. Ironed linens absorb moisture well enough to hold humidity to a safe level. In the tropics, however, neither the suitcase nor the camera should be left in a hotel closet, for moth- and mildew-repellent compounds are often put there to protect clothes, and the vapor of these substances may react adversely with the dyes in color film. A slight amount of contaminated air may even remain in the camera long after it is taken from the hotel closet and even this trace of vapor is sufficient to continue to harm color film.

Much more reliable than ironed shirts as a defense against high humidity is a chemical drying agent, such as silica gel. Crystals of silica gel (white in their natural state but often treated with a bluish indicator dye) can keep the air in a small enclosed space as dry as Arizona. When the gel has collected all the moisture it can hold, the treated crystals turn reddish. But their humidity-countering powers can be revived by cooking them in an oven at 400° until they become bluish again. Silica gel is practically an ideal product: it is cheap; it can be reused indefinitely; and it is available at most photography supply stores, which sell it in small cans the size of shoe-polish tins, as well as in perforated plastic bags and bulk quantities.

On an extended trip in hot, wet climates, some photographers store equipment and exposed film with two or three perforated shoe-polish-can-sized containers of silica gel inside 10-gallon cans of the kind used for paint; their tight-sealing lids make them thoroughly moistureproof. A large, wide-mouthed glass or plastic jar with a vapor-tight cap will also serve as an excellent container for film and small items of equipment if silica gel is included. And even a Styrofoam picnic hamper, despite its lack of a tightly fitted lid, will usually remain sufficiently dry if it contains a liberal amount of fresh silica gel.

When silica gel is not available, ordinary rice can substitute as a drying agent, although about eight times as much will be needed. Before putting it in the hamper, first dry the rice over a low flame, then cool it in an airtight container so that it will not immediately absorb the moisture of the surrounding air. For convenient packets to hold rice or bulk quantities of silica gel in a hamper or equipment case, try ordinary socks; moisture is easily absorbed through the fabric of the socks, and there is no problem of loose grains or crystals scattering about.

Text continues on page 20

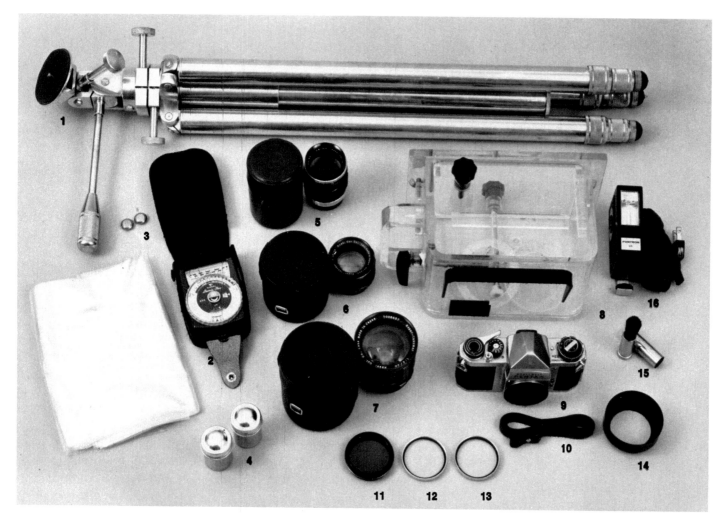

Choosing photographic gear for a trip is like packing clothes: the traveler should be prepared for many different situations, but not overburdened. The 35mm kit shown above can handle almost any situation an amateur is likely to run into. It includes three lenses: long, normal and wide-angle. A small electronic flash unit permits pictures in dim interiors. The plastic bags are useful to seal equipment and film against moisture or dust; but if very harsh conditions are anticipated, an underwater housing, costing $50 or so, is worthwhile.

1 | lightweight tripod
2 | light meter
3 | spare batteries for meter
4 | film
5 | long lens and case (105mm for 35mm camera)
6 | normal lens and case (55mm for 35mm camera)
7 | wide-angle lens and case (35mm for 35mm camera)
8 | underwater housing

9 | 35mm single-lens reflex camera
10 | leather neck strap
11 | polarizing, antiglare filter
12 | skylight filter
13 | haze filter
14 | lens hood
15 | camel's-hair brush
16 | electronic flash unit

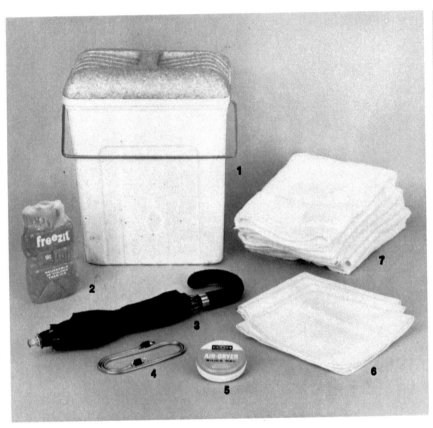

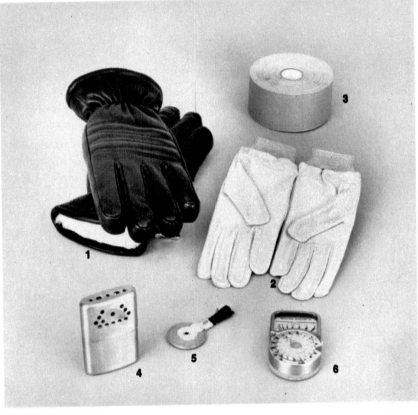

A trip to hot, damp regions calls for several additions (above) to the general-purpose gear shown at left. A foam plastic picnic hamper provides a cool container for equipment and film, and its temperature can be further lowered by packing it with refreezable units of liquid refrigerant. In direct sunlight moistened white towels thrown over the hamper help hold its interior temperature down. Towels can also be worn around the neck to keep perspiration off a camera. Other vital defenses against moisture include lint-free handkerchiefs for wiping the camera, silica gel desiccant to keep film dry, and an umbrella—the convenient, telescoping kind—for rainy weather. A metal neck strap is the best kind for carrying the camera, since leather straps may rot in hot, wet climates.

1 | **Styrofoam picnic hamper**
2 | **refreezable refrigerant**
3 | **umbrella**
4 | **metal neck strap**
5 | **silica gel drying agent**
6 | **lint-free handkerchiefs**
7 | **white towels**

In very cold climates, several extra accessories make it much easier to handle a chilled camera. Two pairs of gloves should be worn—a thick outer pair, and a thin inner pair that will enable the photographer to load or adjust his camera without directly touching the cold metal. The inner gloves shown above are made of aluminized fabric like that used for astronauts' spacesuits, but gloves made of silk, nylon or cotton will do. Since these thin gloves do not offer much protection against the cold, a hand warmer will be welcome after each loading session. Any metal parts of the camera that would touch the photographer's skin should be covered with the adhesive tape called gaffer tape. A stiff-bristled typewriter brush is an excellent aid for clearing snow from the camera's crevices. Light meters should be of the battery-less selenium-cell type, since batteries tend to lose their power in cold weather.

1 | **outer gloves**
2 | **inner gloves**
3 | **gaffer tape**
4 | **hand warmer**
5 | **typewriter brush**
6 | **selenium-cell light meter**

Far more troublesome than humidity, hot or cold, is water in any form—mist, rain, perspiration or ocean spray. When water gets inside a camera, it can rust metal parts, spot the film and cause other sorts of havoc such as shorting out the electrical circuit of the light meter. Perspiration is a worse offender than rain, for it contains salts and acids that quickly corrode metal. Prolonged exposure to salt spray is a foolproof recipe for rusting a camera.

In sweaty weather, many photographers wear towels around their necks so that perspiration does not drip into their cameras. Since hands will perspire, too, leaving salty moisture on camera surfaces, the camera should be wiped periodically with a lint-free cloth or chamois. Neck straps and camera cases made of leather are also prey to perspiration. Frequent waxing of the leather will help prevent rotting, but it is not a certain remedy in extremely damp climates. Co Rentmeester once went through seven neck straps in 10 days when he was shooting a story for LIFE on orangutans in Borneo *(right)*. The solution to the neck strap problem is simple: use a metal one.

In rainy weather some photographers wear a raincoat several sizes too large so that equipment can be comfortably carried underneath; but for all-around convenience, nothing beats an old-fashioned umbrella. However, it is no mean feat to hold an umbrella and shoot a picture at the same time, and occasionally the camera must be bared to the raindrops. A lens hood will usually keep the rain from getting on the lens and blurring the photograph. After the picture has been snapped, the camera should be dried out as soon as possible to prevent corrosion. Wiping it with a lint-free cloth will get rid of some of the water. Later, when the weather has cleared, the camera should be aired and then left out in the sun for a short time to exorcise the last of the moisture. A camera can also be dried in an oven for a few moments at a very low heat, but this procedure must be performed with caution.

Plastic bags—the self-sealing transparent ones used for food storage—provide very effective shields against rain or salt spray, and they are ideal containers for camera, lenses and film in a driving rainstorm, out on a boat or near the surf. It is even possible to keep a plastic bag over the camera while shooting. Just cut a hole in the bottom of the bag, making it large enough for the lens to peek through, then place a rubber band around the hole to clamp the bag to the lens and look through the open end of the bag to use the viewfinder for framing and focusing.

If a camera actually falls into salt water, it stands little chance of survival. Drying it out will not help. The only hope is to rinse it thoroughly, then keep it immersed in a pail of fresh water and get it to a camera repair shop as fast as possible. The immersion may seem suicidal, but it actually prevents air from reacting with moist salt and oxidizing the metal.

The ultimate in camera protection is afforded by a waterproof housing of

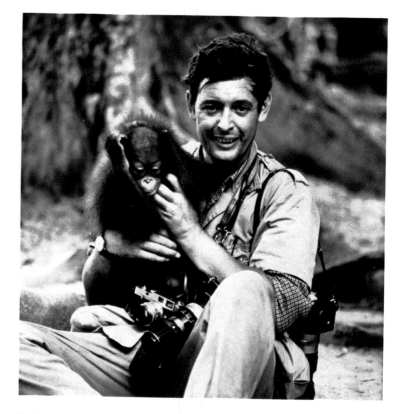

In the steamy atmosphere of a Borneo wildlife preserve, Co Rentmeester found an exceedingly friendly subject in one baby orangutan. Only about 4,000 of these primate relatives of man survive in the rain forests of Borneo and Sumatra.

the kind scuba divers use for taking pictures underwater. The housing consists of a rigid plastic box with a distortion-free glass front and attachments that enable the photographer to focus, advance the film and change exposure settings while the camera is sealed inside the box. (A housing that lacks these controls is considerably cheaper, but the camera has to be removed and reset after each shot.) Sealed in an underwater housing, a camera is totally watertight. It can be carried beneath the sea to a coral reef, plunged into a stream to photograph fish, or used for above-water situations that seem to be a prescription for disaster—such as standing close to a waterfall or leaning over the side of a sailboat to get a wave-level view of racing.

The main drawback of an underwater housing is its bulkiness. It is just not the sort of rig that lends itself to quick shooting or comfortable field work. If flexibility is essential and extremely wet conditions unavoidable, a better choice is an underwater camera such as a Nikonos, which looks like an ordinary camera but is totally waterproof.

Since wetness is so obviously harmful, logic suggests that photographic gear will be safe in very dry climates—but this is not the case, for dry weather usually means that dust or sand particles are floating or blowing about. Blowing dust and sand can etch the surface of a lens, gradually reducing its ability to give clear pictures. In addition, the fine, airborne particles penetrate the crevices of a camera. Once inside, they may jam the film-advance mechanism, slow down the shutter, or coat the inner surfaces of the lens so that light transmission is impaired. The dust may also get on the film, coating it with spots that block light and cause speckled pictures.

An indispensable safeguard for dusty regions is a clear or skylight filter kept over the lens at all times. Since these filters do not significantly affect the transmission of light from the subject, there is no need to calculate new exposure settings—and the filter shields the expensive lens against the direct assaults of flying particles. (Such filters are also very useful in wet environments to guard the lens against dried salt.) Dust and sand can be quickly blown or wiped away with a cloth or even the photographer's tie. The filter may not last long in a very dusty or sandy environment under such treatment, but a new one costs only a few dollars.

Not only the lens, but all other equipment needs protection from dust in dry regions. A coat or blanket can be thrown over photographic gear when it is not in use, but a case or plastic bag affords better protection. Despite the most meticulous precautions, however, some particles will probably find their way into a camera sooner or later, and the interior should always be checked before a new roll of film is loaded. Luckily, dust and sand are not particularly difficult to remove from a camera's innards. The simplest meth-

od is to blow them out by lung power—but there is always a danger that saliva will get into the camera. It is much safer to remove the offending particles with a sable or camel's-hair brush. A more effective device, available at most photography stores, is a rubber bulb that emits a stream of air when it is squeezed; on the opposite end of the bulb is a camel's-hair brush to clear away any particles that remain behind.

In very cold climates, the photographer has to run yet another gantlet of difficulties, which are often just as arduous as those encountered in hot, humid, wet or dusty environments. Shutters slow down, lenses ice over, exposure-calculations become mystifying, film snaps or is marred by electrostatic discharge, and the photographer himself runs the danger of frostbite from touching a freezing camera. However, several potential troubles can be eliminated by careful advance preparations.

One such problem is the slowing of a camera's shutter. Occasionally a chilled shutter does not operate as fast as the setting calls for, resulting in overexposure. In some cameras this lethargy is caused by the material used for their focal-plane shutters. It becomes so stiff and brittle at low temperatures that it resists movement; such cameras should be left at home. More often, the problem is due to thickening of the oil that lubricates the shutter mechanism. This happens less frequently nowadays because most new camera lubricants contain silicones, which do not become stiff until the temperature reaches −60°. Nevertheless, it is wise to check the camera before a winter trip to ski resorts or to northern Alaska. A convenient way of gauging cold-weather performance is to put the camera in the freezer compartment of a refrigerator for several hours, then take pictures at various shutter speeds. If any pictures come out overexposed, the camera should be handed over to a repair shop, where an expert will winterize it by removing most of the lubricants. (When the camera is brought back to a temperate climate, the lubricants have to be replaced to avoid wear and tear on the mechanism.) It is also good policy to have an expert make sure that a camera is perfectly light-tight. In snowy regions, where bright light is reflected from all directions, even a seemingly insignificant light leak can fog negatives.

Other hazards await as the camera becomes cold in the chill outdoors. One common mistake is to take warm equipment out into blowing snow. Snowflakes strike the camera, melt on contact and then refreeze. The only way to get the ice coating off is to take the camera back into the warm indoors. Yet this problem can be easily avoided by giving the camera time to cool down before taking it out of its protective case. When the metal surface is cold, snow that gets on it will not stick and can be shaken or brushed off.

Even after the camera has chilled to a low air temperature, freezing prob-

lems remain; they are simply different. For one thing, the lens ices up if the warm vapor of breath gets on it—as often happens when f-stop adjustments are being made. The moisture will instantly freeze when it touches the cold glass, but it can sometimes be removed by breathing on the lens again and then immediately wiping the remelted droplets off with a cotton cloth. More serious is the possibility that human skin will freeze to very cold camera surfaces. If a photographer puts his eye to an uncushioned viewfinder or tries to adjust the camera controls with his bare hands, his flesh may actually stick to the metal. To counter this hazard, tape sponge rubber, chamois or felt to the camera wherever it is likely to be touched. Another wise safeguard is thin silk or cotton gloves worn under the usual heavy gloves or mittens. The inner gloves not only keep hands warmer when the outer ones are removed, the thin ones make much easier—and safer—the loading and adjustment of a camera in sub-zero weather.

One almost certain casualty of cold is the cadmium-sulfide type of exposure meter—the kind built into most cameras. It operates on batteries, which not only lose power at low temperatures but are further drained by the heavy demands of the cell's reaction to the bright light of snowy regions. Spare batteries, carried in an inside pocket where body warmth maintains their strength, provide some insurance against meter failure. But a much better course of action is to use a selenium-cell meter, which has no batteries and hence is affected less by the cold.

Even with an accurate meter, there is a tendency to overexpose pictures in snow-covered terrain (as well as at the beach or in the desert), because reflectance of light is much higher than in an ordinary landscape. But if the picture includes a relatively dark subject—such as a person standing in the snow—underexposure rather than overexposure is likely. The strong light from the snow will distort the meter reading, and the person will come out dark and lacking in detail. To avoid underexposures, the meter should be held close to the person's face or clothes—or to the back of the photographer's hand, which has the same degree of reflectance. But the best course is extensive bracketing of all exposures.

A skylight filter is a useful aid to correct exposure in wintertime. It is almost colorless, but cuts down on the invisible ultraviolet light scattered by air molecules in the atmosphere; the reduction in ultraviolet helps prevent overexposure, darkens the sky in an attractive way, and also keeps the snow from appearing artificially blue in color pictures—an effect due to the reflection by snow crystals of the sky's ultraviolet, which registers as blue in color film. On the ski slopes, a skylight filter is indispensable because there is so much ultraviolet light at high altitudes that overexposure is very likely.

The film itself picks up peculiar ailments in extreme cold. Its sensitivity is

not particularly affected, but it becomes very brittle. The edges of film hardened by the cold are so sharp that they can cut fingers during the loading operation. In the camera, the film must be advanced and rewound slowly or it will snap. When LIFE photographer Hank Walker was covering the Korean War in wintertime *(right),* his film often snapped because he advanced it too quickly during action-packed moments. He found that such mishaps could be greatly reduced by putting his cameras beneath his parka between shots; his body heat warmed the film and made it less brittle. Cautious movement of the film also avoids another cold-weather problem: electrostatic discharge. Moving film acts just like the rubbing surfaces in the electrostatic generators used for laboratory experiments; an electric voltage builds up on it, and a spark may actually leap from the film to the camera body, resulting in branchlike markings on pictures.

One final danger lurks at the end of the day's shooting in cold climates. If a chilled camera is taken back into the warm indoors, the moisture in the warmer air may condense on the lens, on the film and on the delicate inner mechanisms of the camera. The moisture may corrode the camera or spot the emulsion; and if the camera is taken back outside before the moisture has had time to evaporate, it will freeze solid and make picture taking impossible. The solution is to place the camera in an airtight plastic bag before going indoors. Moisture will condense harmlessly on the outside of the bag while the equipment inside warms up.

Some tactics apply to the problems of all climates. Certainly the first and most important rule does: keep the camera clean. Regularly use a cloth or camel's-hair brush to rid it of moisture, dirt or dust so that it does not fail at some crucial moment. It is bad enough to have picture quality slowly go downhill as camera performance deteriorates, but it is even worse to miss a great picture because the camera suddenly, without warning, refuses to work. Some camera failures that occur in the field can be remedied on the spot. The old trick of making a portable darkroom out of a coat, for example, may save the day when film jams after half a roll has been shot. The technique is simple: place the camera on the coat; button and fold the coat in such a manner that no light reaches the camera; reach backwards through the sleeves to open up the camera back; then free the film from the sprockets of the take-up spool and wind it back into its light-tight cassette. With the film thus rescued, the photographer can remove the coat and go to work on the camera to eliminate the source of trouble—perhaps a bit of sand or dirt that has gotten into the mechanism.

There are several other kinds of first-aid treatment for cameras. A small screwdriver often comes in handy to tighten up screws that have shaken

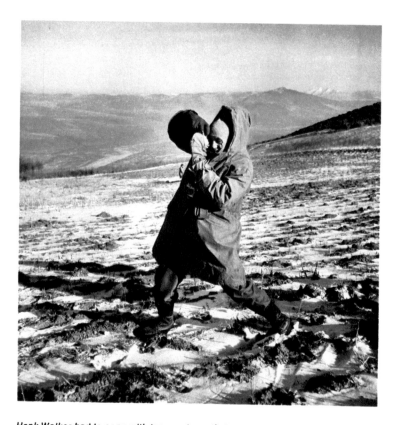

Hank Walker had to cope with temperatures that occasionally dipped to −30°F., while on assignment with an American patrol near the Yalu River (background) during the Korean War. In such extreme cold, film grows brittle. Film breakage was Walker's major problem.

loose during a trip across rough country. A roll of gaffer tape *(page 19)* is particularly useful. Tape helps to seal the crevices of a camera in very dusty regions. And if a camera has been accidentally dropped, bending the camera back so that light can penetrate it and fog the film, tape will provide a temporary seal until repairs are possible.

First aid will not always do the trick, of course, and the time may come when a photographer has to resign himself to the loss of a camera. To cover such an eventuality, professionals working with SLRs almost always carry a spare camera body (that is, a camera minus the lens). It provides an invaluable backstop and is not nearly so expensive as might be thought. The spare need not be an exact duplicate of the camera body ordinarily used. A less expensive model—perhaps lacking a self-timer or a very fast shutter—will be fine for back-up purposes, as long as it takes the same lenses the regular camera does. A secondhand body is generally good enough and may cost only half as much as a new one. But before starting out on a trip, have it checked out at a camera shop and then shoot a roll or two of film with it to compare its performance with that of the regular equipment.

The need for special gear and precautions to neutralize the hazards of nature may suggest that the camera should be left on the shelf at home except when the weatherman guarantees a perfect June day. Far from it. Most of the steps that safeguard equipment are simple. And some of the best pictures are obtained under the worst conditions. Photographers who surmount the problems of the environment find visual glories—the soft light and rich colors of rainy weather, the starkness of desert and plain, the translucent waters and dark tangle of the tropics, the fury of surf, the purity of snow. The difficulties are more than matched by the prize. □

The Challenge of Nature at Its Worst

Professional photographers have been engaged in an endurance contest with nature ever since their craft began, willingly accepting punishment of themselves and their equipment in an effort to get unusual pictures. More than a century ago, travelogue photographers ventured into the broiling heat and biting sand of the Sahara, across the snow of the Russian steppes, and up to the chilling winds of the Swiss Alps, bringing back exotic views that delighted a huge audience of stay-at-homes. Getting a good photograph under such climatic conditions was a difficult business at best. The collodion emulsion of wet plates—a predecessor of modern film—sometimes boiled in hot regions or hardened and became insensitive where the air was very dry. Countless pictures were spoiled when the emulsion picked up flying dust or when a drop of perspiration fell on the plate.

The invention of dry, roll film and rugged cameras has freed photographers from many of their former worries. But predictably enough, the professionals continue to reach for the outer limits of endurance. Today they tote their cameras to the South Pole where temperatures may sink to −100°F.; they defy the fury of hurricanes; they press close to erupting volcanoes; and they will undoubtedly follow the astronauts to the airless mountains of the moon if they can wangle transportation.

Like battle-wise soldiers, they have learned dozens of small ways to protect their gear. Thus armed, today's professional photographers have bested the worst that nature can present—and have brought back from their arduous campaigns such trophies of rare beauty as the ones on pages 27-42.

Heeding Death Valley's reputation for ▶ furnacelike heat—so intense at midday that the color balance of film might be affected—Charles Moore photographed the California desert between 5:30 and 7 in the morning, before the temperature rose above 80°. Even at that hour, the glare of the barren dunes required him to shoot at one or two f-stops smaller than the normal reading. A clear filter protected his lens from flying sand, but some tiny particles penetrated the crevices of his Nikon, and he had to clean out the camera later with a brush.

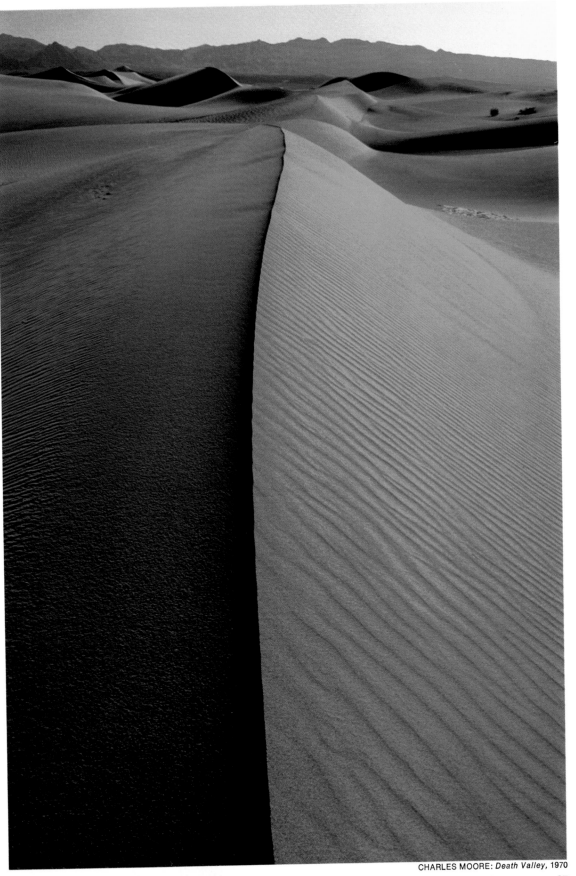

CHARLES MOORE: *Death Valley*, 1970

A Volcano's Spectacular Hell-Fire

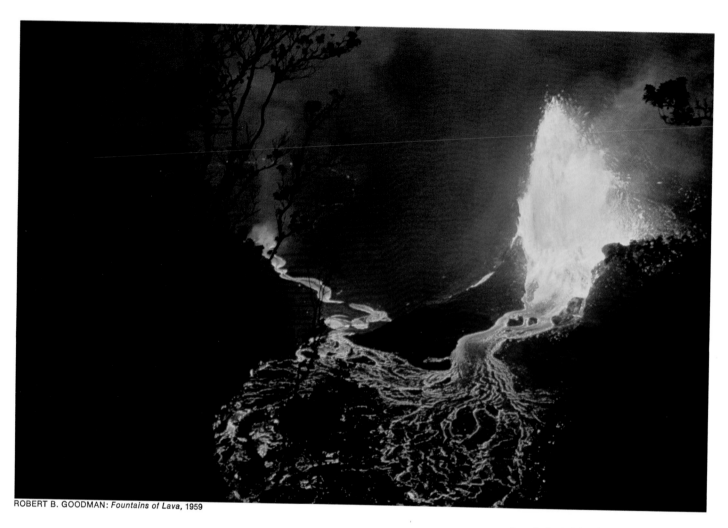

ROBERT B. GOODMAN: *Fountains of Lava,* 1959

*Despite its thrilling fireworks, the eruption of
Kilauea Volcano in Hawaii seemed like a trial by
torture to Robert B. Goodman, who
photographed it for The National Geographic
Magazine. The shaking earth blurred many
of his exposures, and he used up a pocketful of
lens tissues wiping pumice and rain off the
protective filters over his lenses. He needed
several cameras because grit continually
penetrated and jammed them, even though they
were wrapped with protective tape. When
Goodman came close to the seething lava
(right), the heat was so fierce that he had to
focus and shoot in a few brief seconds,
and then turn his back to recover. Of this
assignment he later said, "Photographing a
volcano is just about the most miserable thing
you can do, but also the most fascinating."*

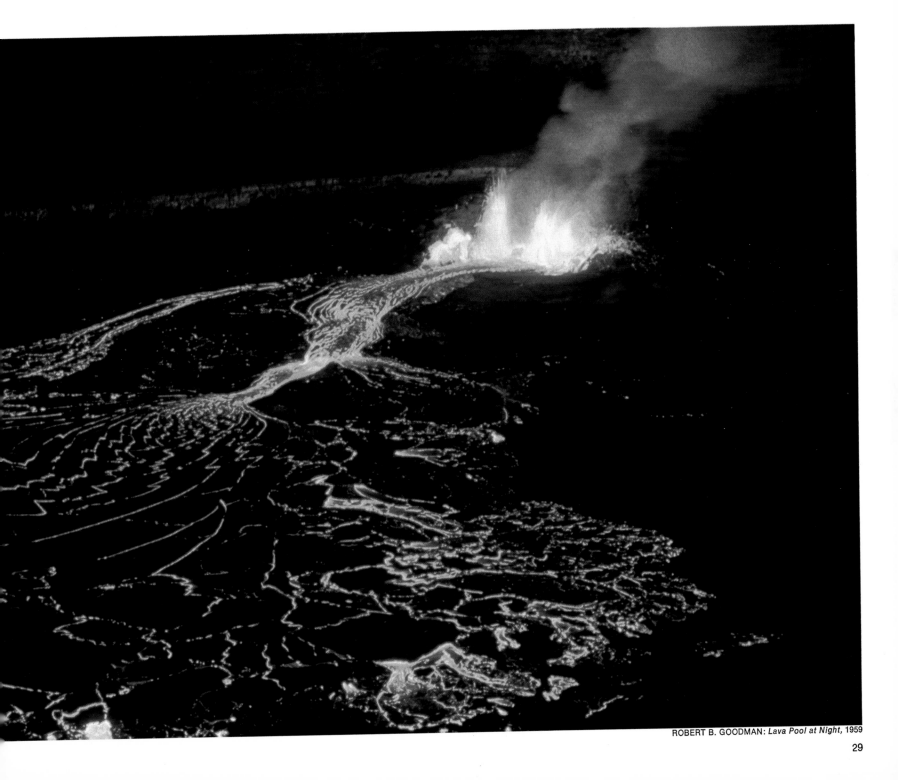

ROBERT B. GOODMAN: *Lava Pool at Night*, 1959

29

The Damp of Sea Air

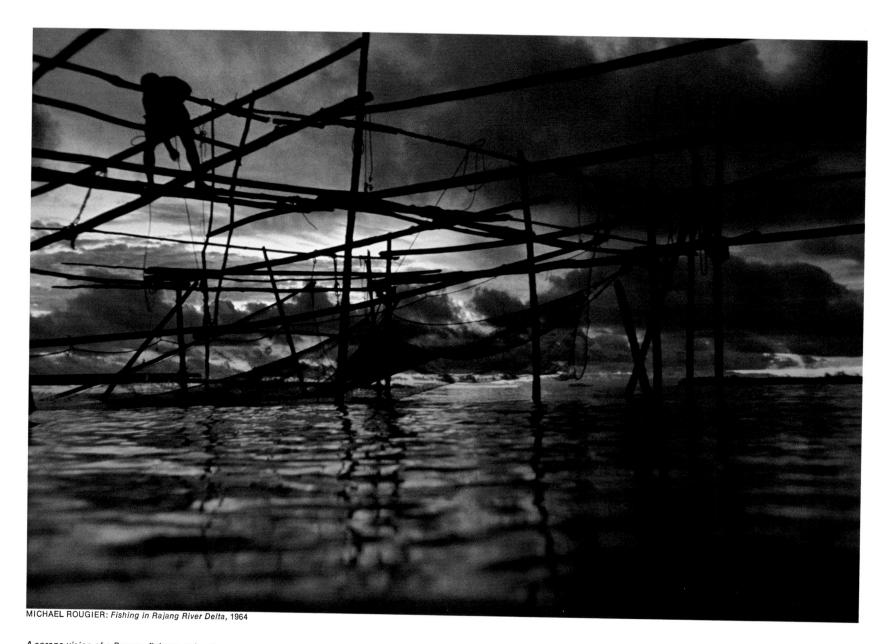

MICHAEL ROUGIER: *Fishing in Rajang River Delta*, 1964

A serene vision of a Borneo fisherman hauling up his nets at sunset belies the difficulties that Michael Rougier faced in this hot, humid climate. To ward off fungus, he carried his film in a picnic cooler lined with packets of the chemical dehumidifier, silica gel. After a day of shooting in the damp air, he used a portable hair dryer to get all moisture out of his camera.

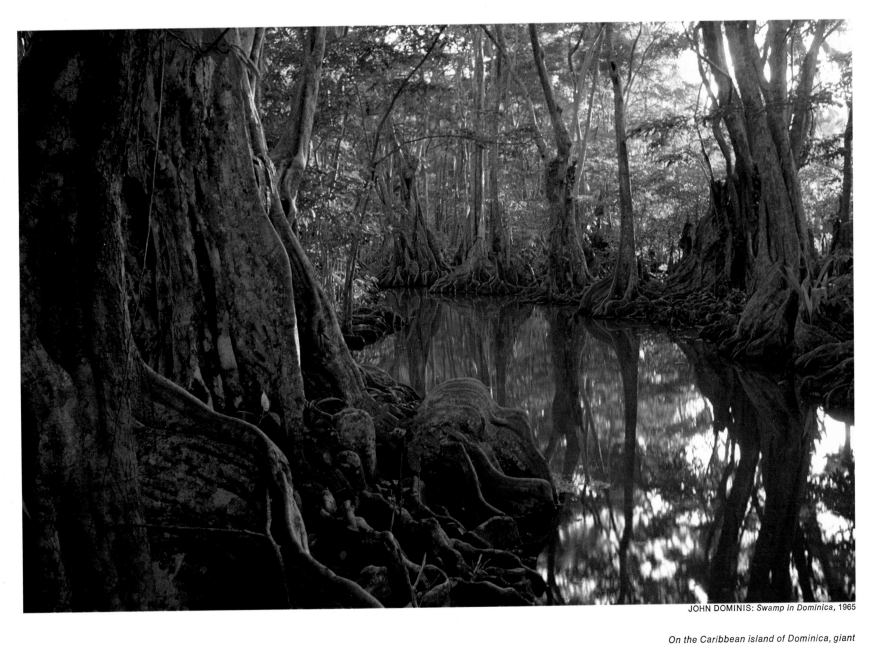

JOHN DOMINIS: *Swamp in Dominica*, 1965

On the Caribbean island of Dominica, giant pterocarpus trees hold within their gnarled embrace an invisible threat to photographic equipment—hot, damp air made salty by the nearby sea. John Dominis minimized the corrosive effect of this atmosphere by keeping his camera in a strong plastic bag and removing it just long enough to shoot the picture.

Dust and Rain in the Tropics

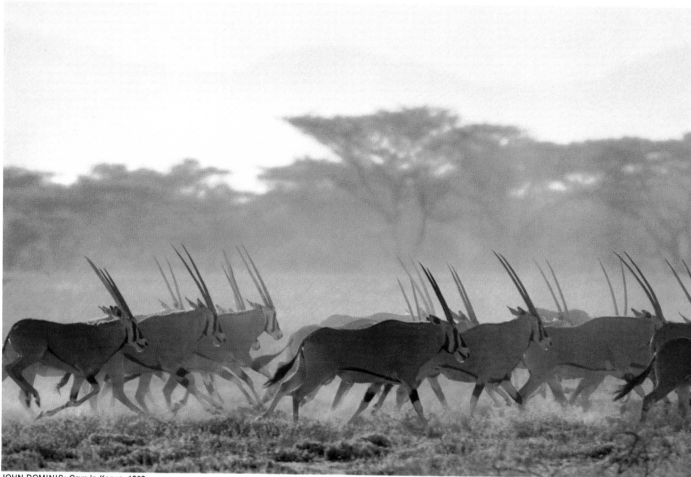

JOHN DOMINIS: *Oryx in Kenya,* 1969

Galloping across the parched grasslands of Kenya, a herd of oryx fills the air with fine, lingering dust. John Dominis turned the choking cloud to his advantage by positioning himself so that the sun was in front of him, backlighting the dust and producing a soft, luminous background almost like fog. He used a long 600mm lens and kept a considerable distance between himself and the skittish antelopes, but dust kept getting inside his camera anyway, and he had to clean it out every night with brushes and an air stream squeezed from a rubber bulb.

Water buffaloes and their youthful tenders calmly endure the whip of rain during monsoon season in Java. The downpour lasted only two minutes, but it proved costly to the photographer, Co Rentmeester. Although he carried an umbrella, wind-blown spray knocked his exposure meter out of action by causing a short circuit and also corroded his shutter so badly that he had to throw the camera away.

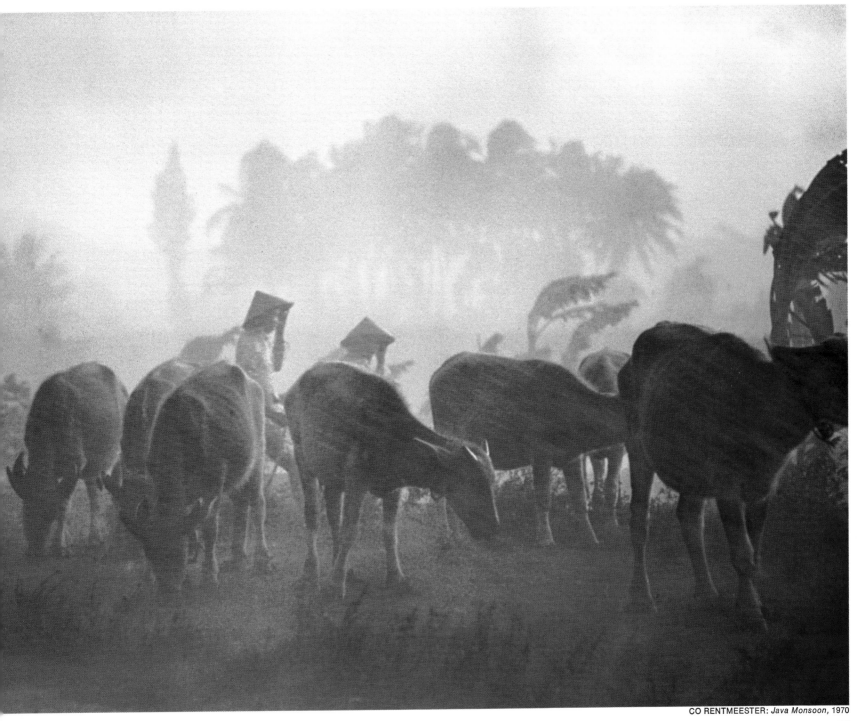

CO RENTMEESTER: *Java Monsoon*, 1970

33

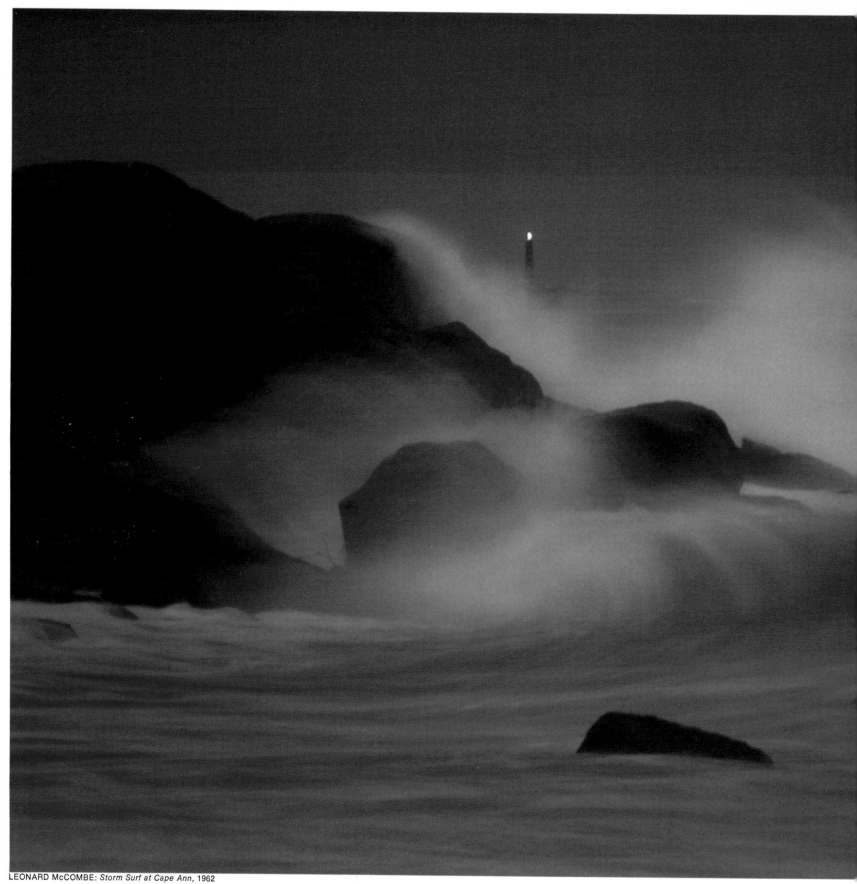

LEONARD McCOMBE: *Storm Surf at Cape Ann*, 1962

Storm-driven waves tear at the granite headland of Cape Ann, Massachusetts, as a lonely beacon in the background warns ships to stay clear. Leonard McCombe shot this picture of the sea's savagery an hour after sunset, using a tripod to steady his Nikon on the rocks. He protected his 200mm lens with a clear filter, wiping off spray just before he released the shutter. Then he quickly covered the camera with a plastic bag that kept out the corrosive spray.

The Challenge of Nature at Its Worst: continued

Dazzling Light, Frigid Cold at the Poles

A whole new set of difficulties lies in wait for photographers who venture into the polar regions of the earth. Not only do low temperatures solidify camera lubricants and make film brittle enough to break if it is not advanced slowly, but the quality of the light is changed so much by snow and the low sun that exposure calculation is particularly demanding. Yet photographers travel to the Arctic and Antarctic in ever-greater numbers—for the simple reason that there is a surprising amount of activity there to be documented.

A million people live in Arctic lands, and unfamiliar species of birds and animals abound. Mining is a thriving industry in the frigid reaches of northern Canada. Tankers *(right)* and pipelines are thrusting into the icy Arctic realm to bring back oil from a pool underlying northern Alaska.

The Antarctic is an even more fearsome place. With an average altitude of 6,000 feet, it is the highest and coldest of all continents, its land and surrounding seas burdened with 90 per cent of the world's ice. Yet 10 nations have set up major camps in this lifeless, frozen land, for Antarctica holds important clues to global weather patterns, geological processes and the history of the planet. Photography plays an important role in all these scientific investigations, and also enables the world at large to see the work in progress. Even amateur photographers can now venture into this bleak region; one travel agency offers a tour of a United States camp that is perched in McMurdo Sound on the edge of the ice pack. □

Crunching through ice floes in the Arctic Ocean, the heavily reinforced tanker Manhattan nears the last leg of a voyage that tested the practicality of shipping oil from Alaska to the East Coast by a Northwest Passage. To get this picture from a viewpoint close to the ice-choked water, John Olson attached his Nikon to a 20-foot pole, held it over the side of the ship, and triggered the shutter with a cable release. He had already removed lubricants from the camera to prevent the shutter from slowing down or jamming in the severe cold. And before he went back indoors, he sealed the chilled camera inside a plastic bag so that moisture from the warm interior air would not condense on it.

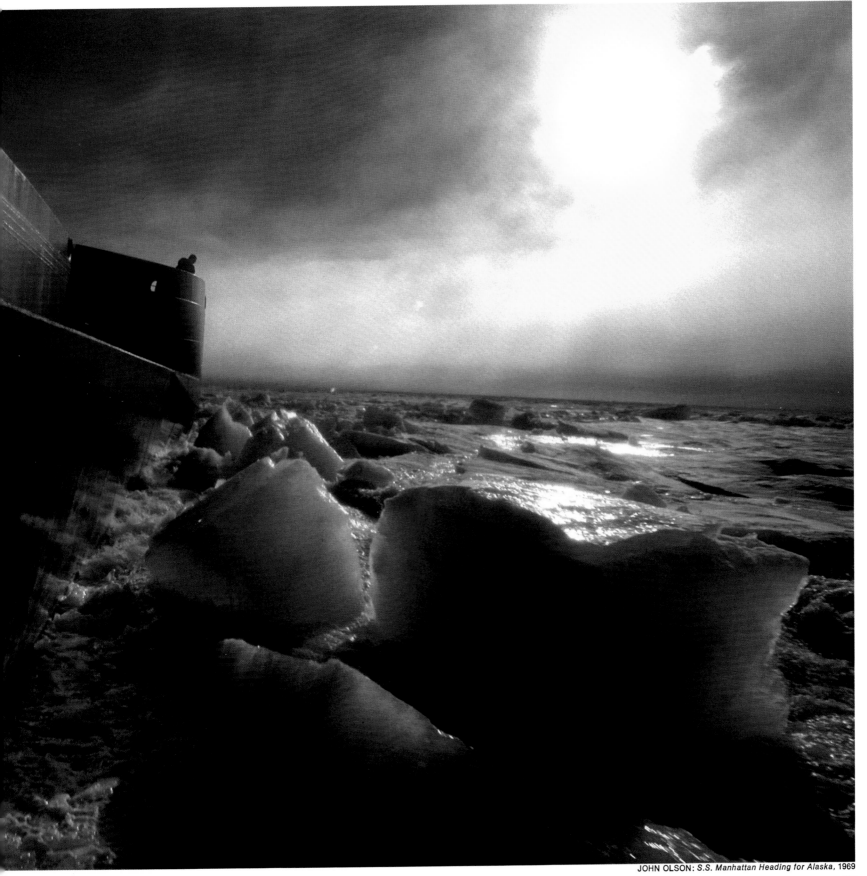

JOHN OLSON: *S.S. Manhattan Heading for Alaska*, 1969

The Challenge of Nature at Its Worst: continued

Exploiting Antarctica's Brilliance

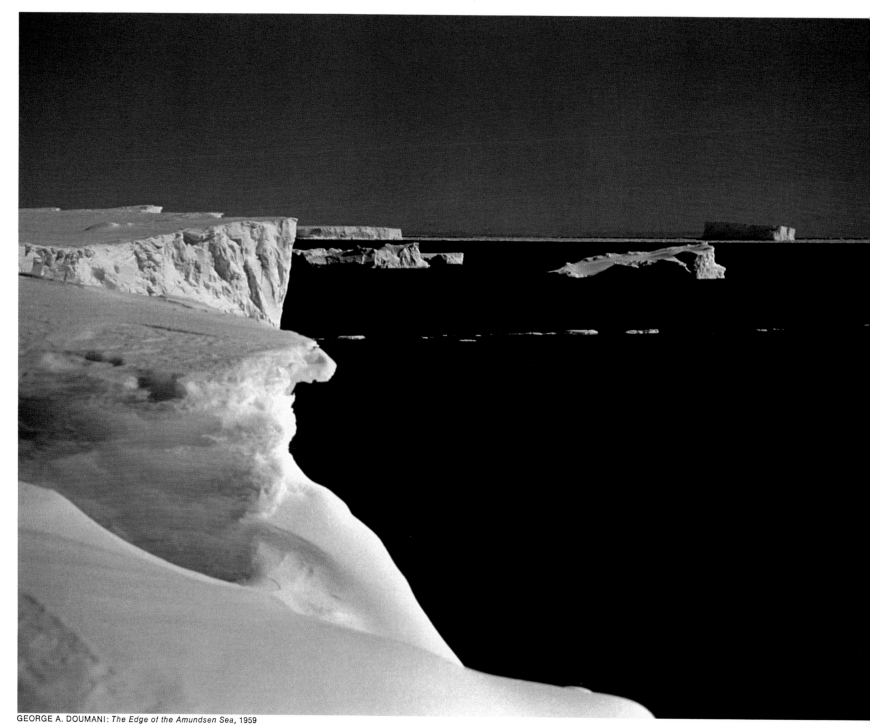

GEORGE A. DOUMANI: *The Edge of the Amundsen Sea*, 1959

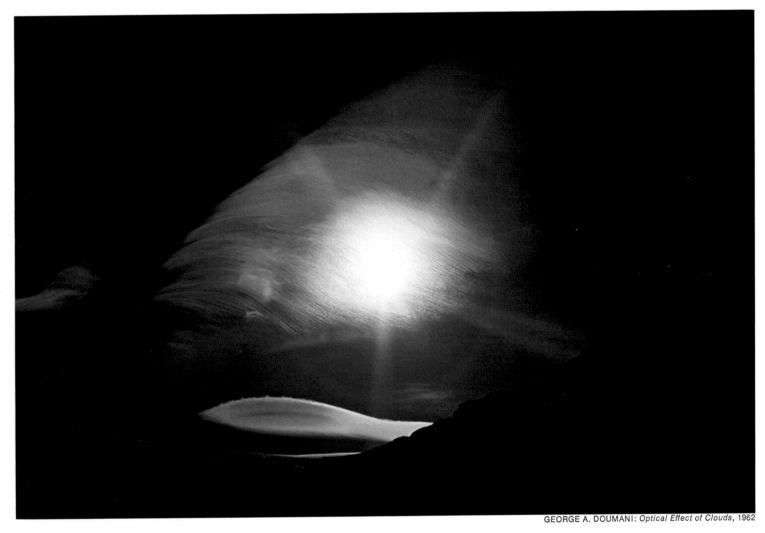

GEORGE A. DOUMANI: *Optical Effect of Clouds*, 1962

An ice shelf at the edge of Antarctica gleams gloriously white in the picture at left, taken by George A. Doumani, who is a geologist and glaciologist as well as a photographer. Using an ultraviolet filter over his lens, he blocked the great amount of ultraviolet radiation that the ice reflected from the sky, and thus reduced the bluish tinge such rays induce in color film. He also underexposed slightly to deepen the blue of the sea and show off the white ice to even greater advantage by heightening contrast.

To capture the unusual rainbow effect often observed around clouds laden with ice crystals, Doumani gauged exposure by pointing his meter directly at the Antarctic sun, then blocked the sun out of the camera's view by shooting from beneath a rock overhang. In effect, he was underexposing by several stops, thus suppressing the whiteness of the clouds and allowing the delicate rainbow colors to show up clearly. His meter was able to handle the direct rays of the sun because they were weakened by traveling a long distance through the atmosphere; in Antarctica, the sun never rises more than 50° above the horizon.

Antidotes for Sub-Zero Wind and Snow

Helicopters were grounded and scientists huddled inside their tents at Byrd Land Camp in western Antarctica when Navy photographer Robert R. Nunley ventured outside to take this chilling picture. The temperature stood at -30°F. and the wind was blowing fiercely. Under such conditions the slick metal of the camera would have instantly frozen to the skin of his face as he looked through the viewfinder of his Nikon, but Nunley averted this danger by covering up the metal with canvas tape. To keep the fine, blowing snow from penetrating the camera, he periodically cleaned the outer crevices with an ordinary typewriter-eraser brush.

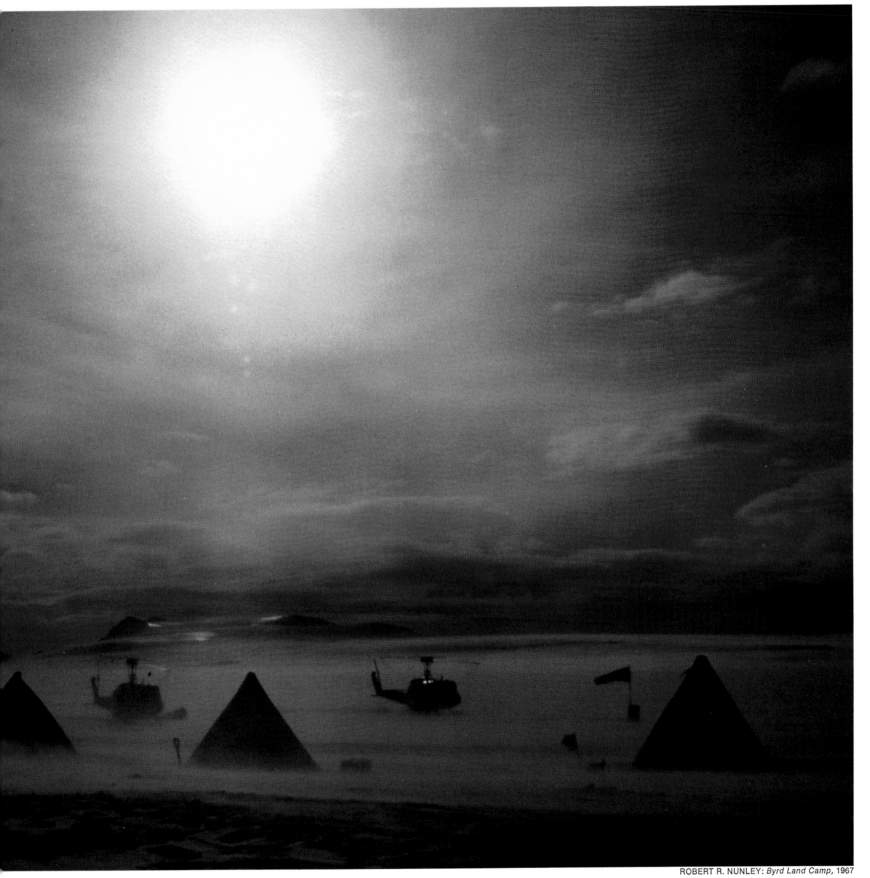

ROBERT R. NUNLEY: *Byrd Land Camp,* 1967

Perils of the "White-Out"

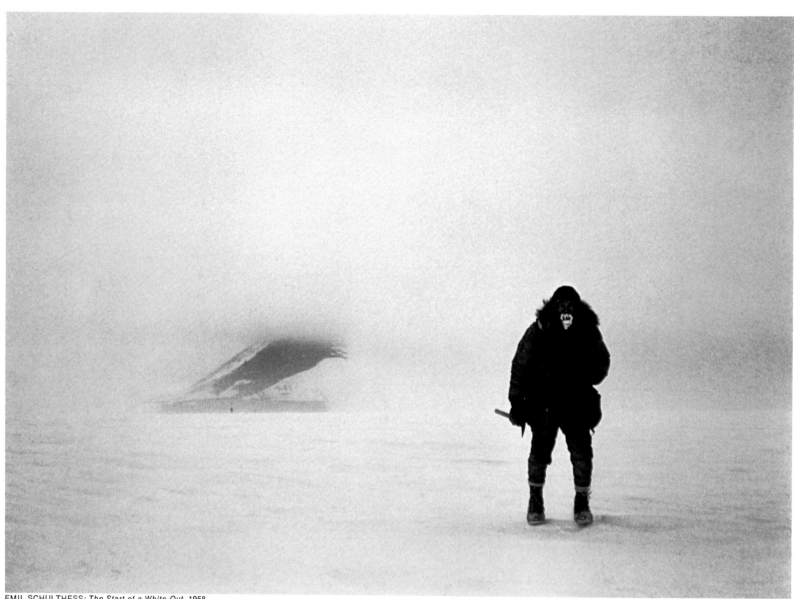

EMIL SCHULTHESS: *The Start of a White-Out*, 1958

A weary geologist, his beard caked with rime, returns from an expedition at the beginning of an Antarctic "white-out"—a perilous, disorienting condition when the reflection of light from the cloud cover and snow is almost exactly equal, and land and sky become indistinguishable. Focusing on the scientist's face with his winterized Leica, and shooting at 1/100 second and f/5.6, Emil Schulthess framed him against the rapidly disappearing horizon.

How to Get the Impossible Picture 46

Making the Foreground Disappear 48

Diffusing Distracting Backgrounds 50

Shooting Past Reflections 52

Shooting through the Looking Glass 54

Ducking Flare 56

Establishing Mood with an Enlarger 58

Far and Near in a Single View 60

Wide Angles, Distortion-Free, with a Special Lens and Camera 62

A Picture Lit by a Match 64

Adapting for High and Low Views 66

Making a Camera Shoot Sideways 68

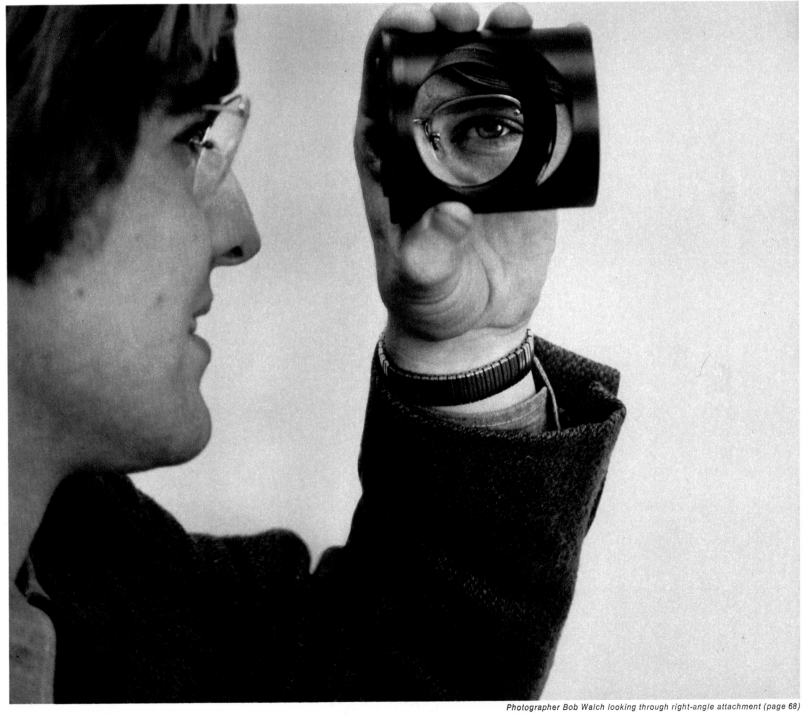

Photographer Bob Walch looking through right-angle attachment (page 68)

How to Get the Impossible Picture

It is often said of problems that everybody has them—an undeniable but not very comforting sentiment. In photography, to be sure, one does not have to be a world-roaming adventurer to encounter difficulties. Problems lurk in the most everyday situations, where there are no glamorously extenuating circumstances, such as Amazonian heat or Antarctic chill, to help explain away a failure. Photographers constantly find themselves trying for interesting kinds of pictures, only to find that various difficulties undo their esthetic intentions. A scene shot through a window, or toward the sun, or into a mirror holds out the promise of special visual excitement, but the picture is very likely to turn out to be marred by distracting reflections, cascading splotches of light, or unexpected blurriness. If a photographer poses a person against a beautiful landscape and then steps close to get a good-sized portrait, the background may well be lost in a blur—and just knowing that it was there will make the picture seem all the more disappointing. Or a picture may fall short of its potential because the photographer didn't know how to deal with a background that was too busy, too bright, or the wrong color.

It is perhaps perversely logical that the most tempting pictures are frequently the hardest to get. Yet photographers need not accept this with a shrug, or rein in on their ambitions, for they have a great deal working in their favor. One of their biggest advantages in working with troublesome settings is mobility. By walking around a subject—a statue or a tree, say—a position can usually be found where distracting backgrounds, unwanted shadows, or flare-inducing lights are eliminated. Shots taken from a kneeling position will silhouette the subject against the clear, neutral background of the sky. A bird's-eye view may give an inkling of the subject's general environment —for instance, locating the statue in a tiled courtyard or the tree on a lawn —while holding back other details of the surroundings in a tantalizing way. And if the subject is mobile too, any setting can be maneuvered into submission, for the photographer will not have to give up a particular angle of view in exchange for ridding the scene of some obstacle.

The camera itself provides all sorts of means for dealing with troublesome surroundings. The most important are the familiar options of aperture size, shutter speed and focal length of the lens. Consider, for instance, the problem of taking a portrait in a city street, a setting with plentiful variety and vitality. In the mind's eye of the photographer, the person in front of his camera is an attention-drawing presence, and he expects the camera to render the subject that way. But the anticipated center of interest may not materialize in the photograph. The person may appear diminished and anonymous in a welter of signs, passing cars and hurrying bodies. Yet these distractions might have been easily nullified. The photographer could have found a quieter backdrop by walking around his subject or posing the person in a care-

fully chosen spot. He could have set the camera diaphragm at a wide aperture, reducing depth of field and blurring the background. He could have selected a slow shutter speed so that the cars and passersby would turn out blurred while his motionless subject remained sharp (provided that the camera was braced against a wall or car to prevent shake). Or he could have taken the picture with a long lens whose narrow angle of view would catch only a small segment of the bothersome background.

This is not to say that a bustling, dynamic background should be divorced from a portrait on grounds of incompatibility. The urban setting may say something quite revealing about the person who is being portrayed, in which case the photographer may want to pursue wholly different tactics—freezing the intricate motions of the city with a fast shutter, extending the depth of field with a small aperture, and perhaps pulling in a generous sweep of view with a wide-angle lens.

A number of specialized camera accessories are available to help cope with difficult settings. Polarizing filters will cut down on reflections; red or yellow filters will enable a camera to peer through mist by blocking the blue and ultraviolet light scattered by water droplets; there is even a split filter —one half red-tinted glass and the other half clear glass—that is designed to darken a sky and bring out the whiteness of the clouds while leaving the lower half of a landscape unaffected so that no detail will be lost. A somewhat similar device, resembling a simple lens cut in half, allows a camera to focus at two different distances at the same time—one possible solution to the problem of getting a background and a foreground both in focus.

Equipment manufacturers are pressing toward a state of affairs where no situation could be said to be impossible. They offer periscopelike lens attachments for shooting to one side or around a corner; they make lenses that can scoop in a very wide-angle view with scarcely any distortion. Even almost total darkness—the ultimate obstacle in photography—has been conquered. Photographers today can employ a device called a low-light-camera system *(pages 64-65)*, which multiplies the intensity of light so dramatically that a short-exposure picture can be taken by starlight.

Making the Foreground Disappear

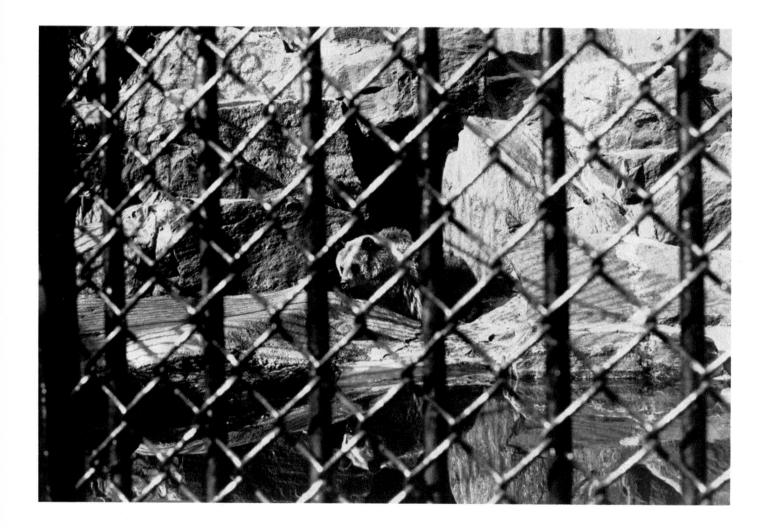

The grizzly bear resting in New York's Central Park Zoo is in sharp focus but can hardly be seen through the bars and mesh shielding his den. Freelance photographer Paul Jensen made this picture as a demonstration, using a small enough aperture—f/11—to provide sufficient depth of field to keep both the foreground cage and the background bear sharp.

Many a potentially interesting photograph is ruined because of distracting obstacles cluttering the foreground. A photographer standing at a window and trying for unself-conscious pictures of children playing in the street may find his view is obscured by the window screen. Such sports events as tennis matches take place in areas enclosed in mesh fences. And animals like the grizzly bear above are most easily found behind the bars of a zoo cage.

Such barriers can be wiped out of the picture by simple focusing changes. If the obstacles are sufficiently blurred, they will not show. A long-focal-length lens, which has restricted depth of field at short distances, makes it easier to throw foreground subjects out of focus. But even with a normal lens, much of the heaviest foreground obstruction magically melts into an almost invisible blur when the aperture is opened wide, or when the photographer moves in

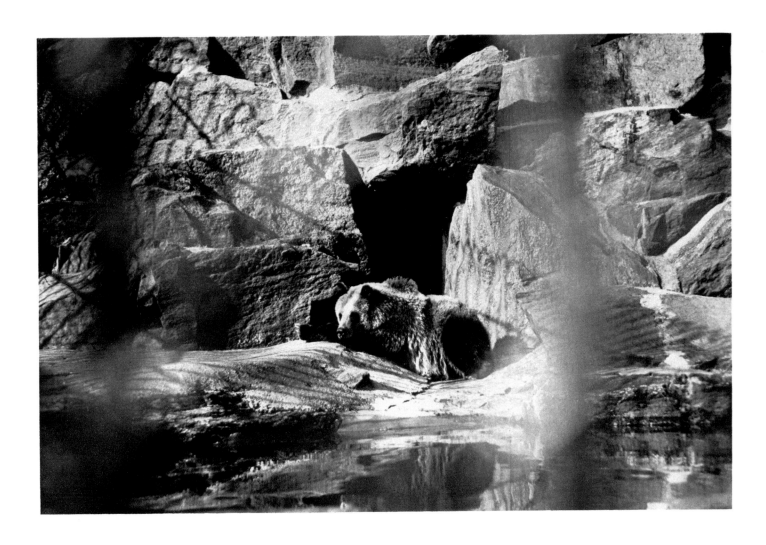

close to the obstacle, and focus is adjusted for the distant subject.

In some cases the photographer may wish to retain a sense of place or to make a point by keeping in his picture a soft suggestion of the foreground obstacles. For instance, he might want to show the hazy leaves of the blind in which he hid to photograph wildlife, or show the bars of a circus cage to emphasize that the lion tamer is right inside with the dangerous animals.

In the picture above, Jensen maintained his focus on the bear, but decreased his depth of field by opening the aperture to f/2.8; he also moved up close to the fence. The links of the cage have practically disappeared, and the thick iron bars, now dim and blurred, are all that remain to show that the bear is caged. Even the bars could be cropped from an enlargement.

Diffusing Distracting Backgrounds

When a busy background spoils a normal composition, there are two simple means of dealing with the difficulty. First, the background can be thrown out of focus by decreasing depth of field until only the subject itself is sharp, clearly delineated in the foreground. A long-focal-length lens, because of its severely restricted depth of field, when used to photograph objects near at hand can help to blur a distracting background, but simply increasing the aperture without changing lenses will have a similar effect.

Second, the photographer can shift position to change the angle of his shot, so placing himself that he can picture his subject against a less cluttered background. On a busy city street, he might move to a point where the background consists solely of a blank wall; in the countryside he can avoid the distraction of a background tree by turning to set his subject against an open field. Choosing a high angle, so that the background is plain ground or pavement is another stratagem. But a common dodge is simply to drop to one knee, shoot from a low angle and silhouette the subject against the sky —the technique that freelance photographer George Haling finally used to obtain the picture he wanted *(opposite, far right)* of a New York traffic sign.

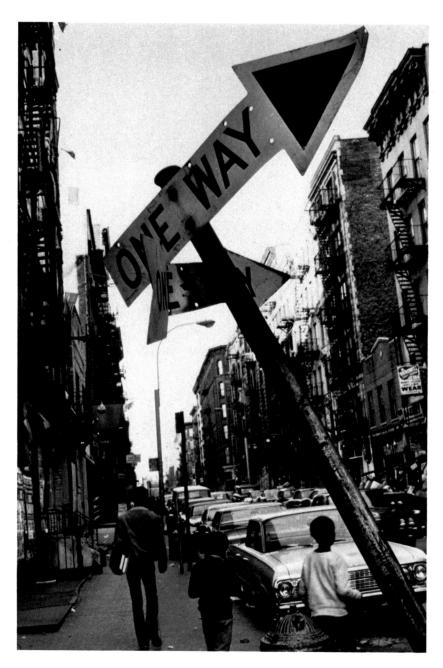

Sharp detail far down a bustling city street is caught in this picture shot at f/32, an extremely small aperture that gives great depth of field. But so clear a background distracts the viewer from the subject: a sadly smitten traffic sign.

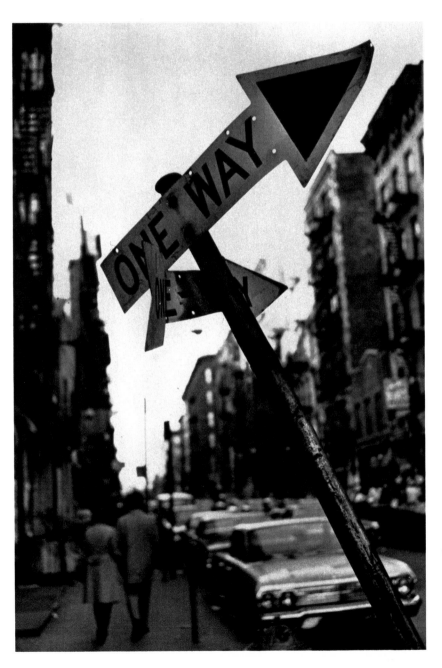

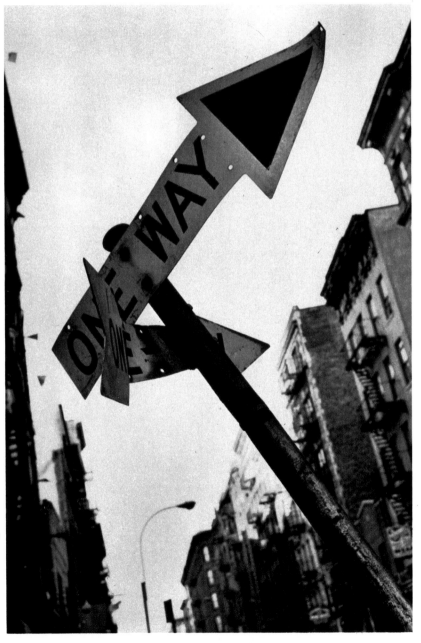

When the lens was opened to f/4, depth of field was so reduced that even the parked car a few feet away from the battered sign was thrown out of focus, and the design formed by its tormented arrows is sharp in comparison.

Changing the angle and shooting upward made the sign's outline stand out as the background virtually disappears. The buildings, fairly sharp at a moderate aperture, approximately f/12.5, now serve only to frame the sign against the sky.

Shooting Past Reflections

 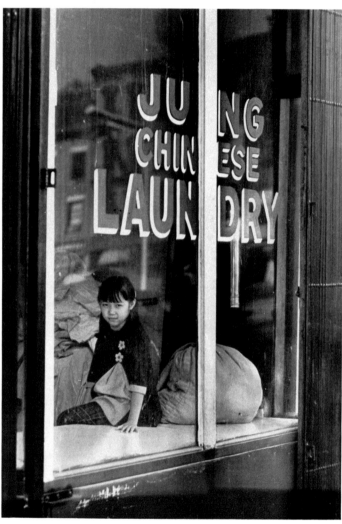

Freelance Bob Walch dextrously manipulated a polarizing filter to control the reflections that make nonsense of the picture at left above. He eliminated just enough reflection in the picture to the right to clear up the lettering inside the window, the condensed steam running down it and the smiling child, still leaving the dim image of the buildings to maintain a sense of place.

There are various ways to overcome the distraction of surface reflections when photographing an object behind a pane of glass. One of the best methods depends on the fact that all reflections from any such nonmetallic surface as glass consist of polarized light —light rays that vibrate only in one plane. The reflection can thus be reduced by a polarizing filter, which blocks off the rays in a single plane of light. It is easy to swivel the filter around until the plane it blocks coincides with the plane of the reflected rays, thus trapping the reflections while leaving the subject clear in the viewer. When taking a picture through a window, a polarizing filter is most efficient if held at an angle of about 35° to the surface, because it is at that angle that

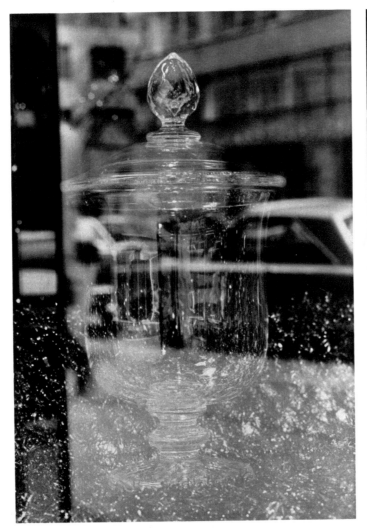 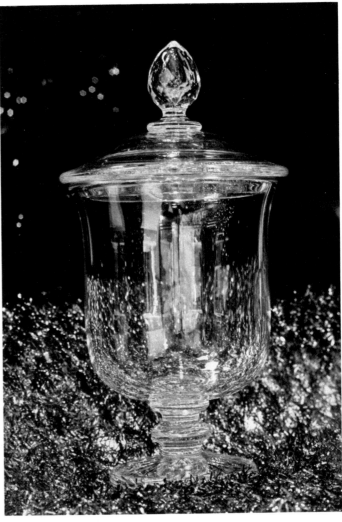

maximum polarization occurs. In order to compensate for the light lost in the blocked rays, open the aperture 1⅓ stops wider than the meter reading.

Without a polarizing filter, the most obvious technique is to move around until obtrusive reflections are at a minimum. But this works only when the camera angle is unimportant, and even this technique will not always work

—especially on bright days. Another method, mainly good for small subjects behind the glass of a window or showcase, is to move close to the glass —even to the point of touching the front of the lens housing to the glass— so that the photographer and camera shield the window, preventing the formation of reflections that the camera can catch (above).

In the first shot (above left) the crystal bonbonnière in a display window is barely discernible beyond dazzling reflections from the street. By moving in close to the plate glass (right), the photographer screened out the reflected car and buildings, while the covered candy dish, as seen in this cropped enlargement, still gleamed with its own reflections, lit from angles he had not blocked.

Shooting through the Looking Glass

The first thing to keep in mind when photographing an object and its reflection in a mirror is the optical law that light from an image in a mirror has to make a double journey: it must travel from object to mirror, then from mirror to eye or film. This doubles the apparent distance between the reflection and the object being reflected, raising focusing difficulties when both are to be included in the picture *(right)*.

Depth of field is again the factor that controls success with such pictures. Changing to a lens of shorter focal length gives greater depth of field, but may introduce size distortions, particularly in close-ups.

Retaining the normal lens but stopping down its aperture is a simpler way to increase depth of field and is often sufficient, provided allowance is made for the range of sharp focus. At distances of less than five feet, focus the camera midway between reflection and real object. At medium distances—5 to 15 feet—focus on a point about a third of the apparent distance between the two. Such a focus makes the most of the available range of sharpness.

The three pictures at right and opposite of a bouquet in front of a mirror show the traps of shooting an object with its reflection—and how to avoid them. All three photographs were taken in natural light, from a sunny window, with a Leicaflex, using a zoom lens set at 90mm. In the first two shots (right and center) a wide aperture, f/5.6, so restricted depth of field that when the camera was focused on the bouquet, the mirror image appeared as a misty blur, and when the focus was set for the reflection, the flowers were blurred. Decreasing the aperture to f/16 enlarged the depth of field, and carefully adjusting the focus—bringing it closer to the foreground than the background—made all parts of the scene come out sharp (far right).

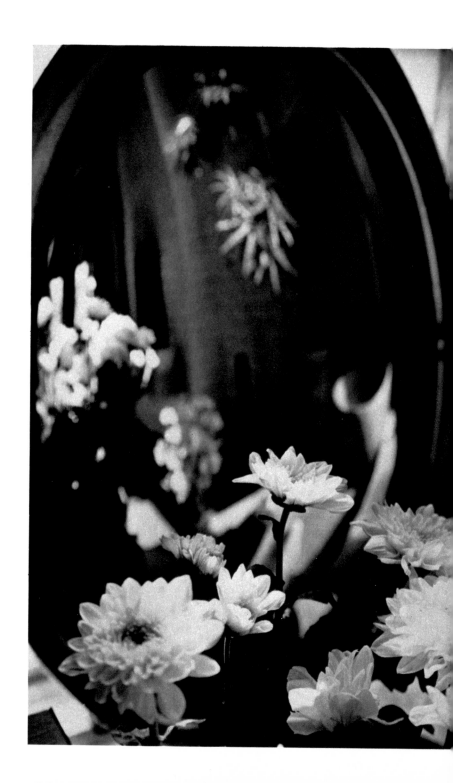

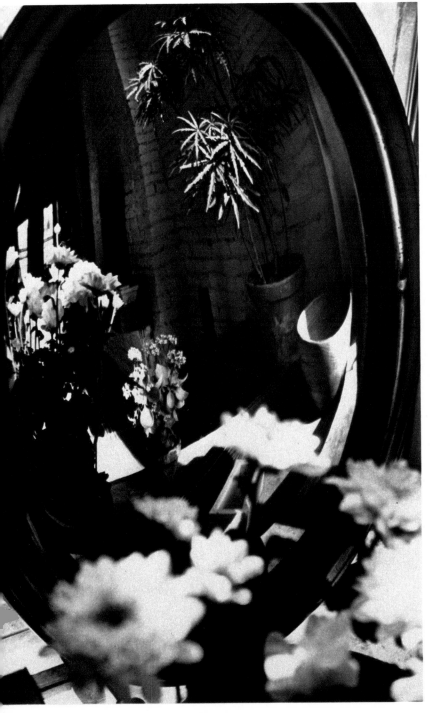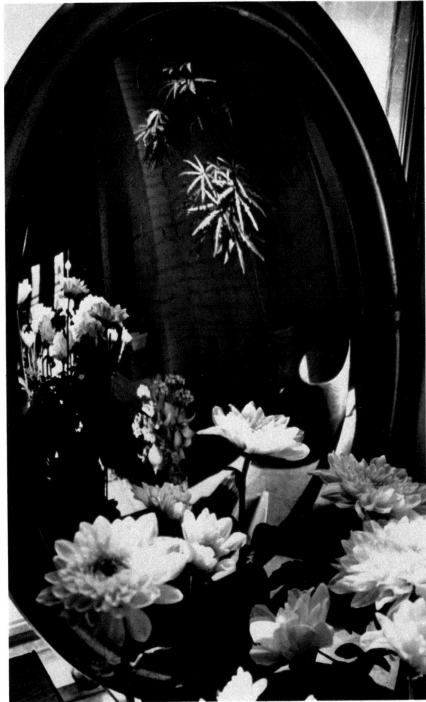

Ducking Flare

Flare—a loose term denoting bright spots on a picture caused by light reflections on the surface of a lens, inside lens elements or in the camera body itself—is normally avoided by obeying a hoary bit of advice: do not shoot directly into the sun or any other light source. This advice is not always easy to follow, and sometimes following it will not solve the problem. If, for example, a photographer is shooting a seaside scene, brilliant light will enter his lens from a variety of sources—from reflections off the water, from the white sand, perhaps from the metal parts of beach gear, as well as from the direct rays of sunlight angling in—any or all of these sources can produce flare spots in the finished picture.

A light source can cause flare even when it is out of the field of view of the picture—oblique rays are bent into the camera by front surfaces of the lens. The wider the aperture the more opportunity for such unsuspected light to enter and to spread. Thus, the photographer who is shooting under conditions in which he suspects flare may occur should use a lens hood, and stop down for as small an aperture as possible. Alternatively, he may solve the problem by changing his position, placing the object he wishes between lens and light source—the simple trick that was successfully employed to take the picture on the opposite page.

Shot into the sun, this attempt to portray the stark outlines of a telephone pole resulted in a classic example of "iris flare." Sunlight entering from the side bounced around the elements of the lens and generated multiple reflections of the hexagonal shape of the open diaphragm of the Nikon F used to take the picture.

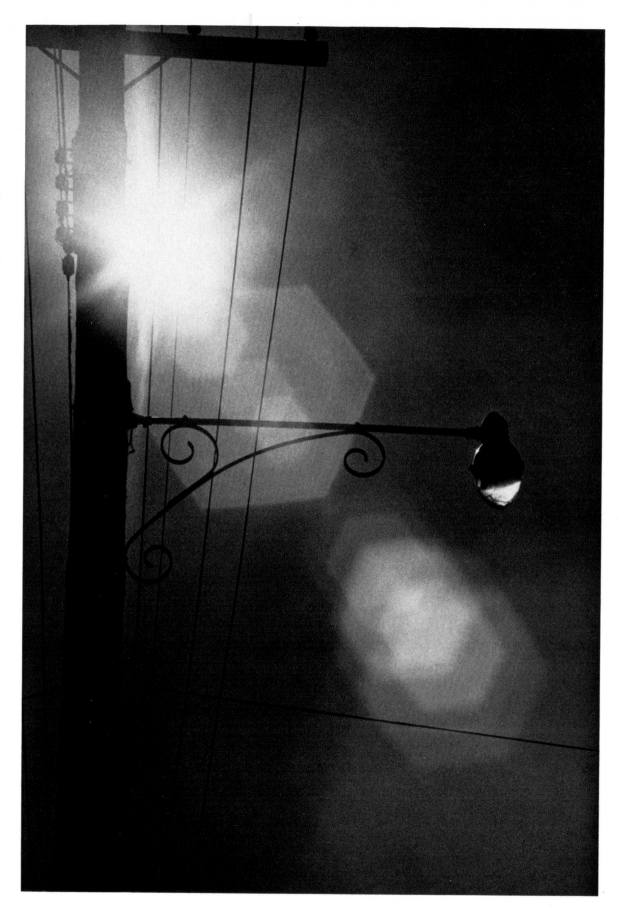

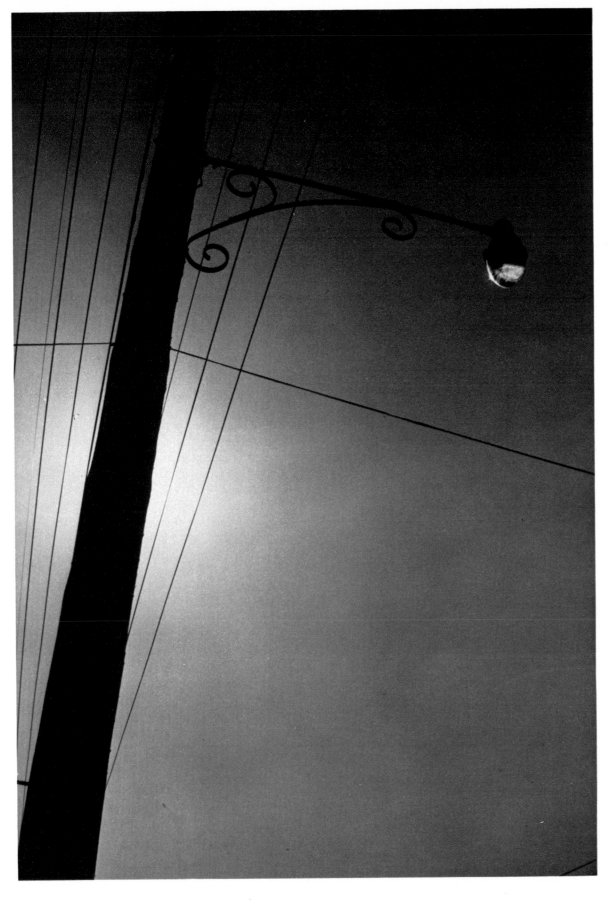

With the camera moved to a position behind the subject, so that it blocked the direct rays of the sun, the photographer was able to shoot toward the light source and still avoid flare—and get the picture he set out to produce.

Establishing Mood with an Enlarger

Some problems in photography can be solved simply by switching from one type of enlarger to another. In pictures, and particularly in portraits, that rely on such subtleties as shading or detail, mood can be significantly altered by the type of enlarger used in printing. Such a contrast shows up in the pictures on these pages. Both prints were made from the same negative; the one at left with a condenser enlarger, the one opposite with a diffusion enlarger.

The diffusion enlarger has a light-dispersing system, usually a milky glass plate between negative and lamp, that is designed to spread light so that it continues to spread slightly after passing through the negative. Since the light rays are diffused when they reach the enlarging paper, details are softened and tones muted. For portraits, such prints are often pleasing because the lack of sharp definition and crisp shadows can be flattering. But some of the light is lost when it passes through the glass plate, requiring an increase in exposure time.

The condenser system is more efficient. Working on the same principle as a spotlight, a pair of condenser lenses focuses light so that the light rays do not spread, making sharp prints with bold contrasts and tones. Where the finest detail is to be rendered, the condenser enlarger is generally the choice.

Made with the intense, focused light of a condenser enlarger, this print is sharp in its contrast and tones. The lighting and highlights are bright, the shadows very dark in the areas under the chin, creating a harsh quality. The brilliance of the light in the enlarger also brings out vividly the texture and sheen of the shirt.

Made from the same negative as the picture opposite, this print shows the gentler tones created by a diffusion enlarger. Well-suited for portraits, the diffusion enlarger softens shadows and facial markings. The shirt texture has receded as a factor in the portrait and the mood of the shot is one of peaceful tranquillity.

Far and Near in a Single View

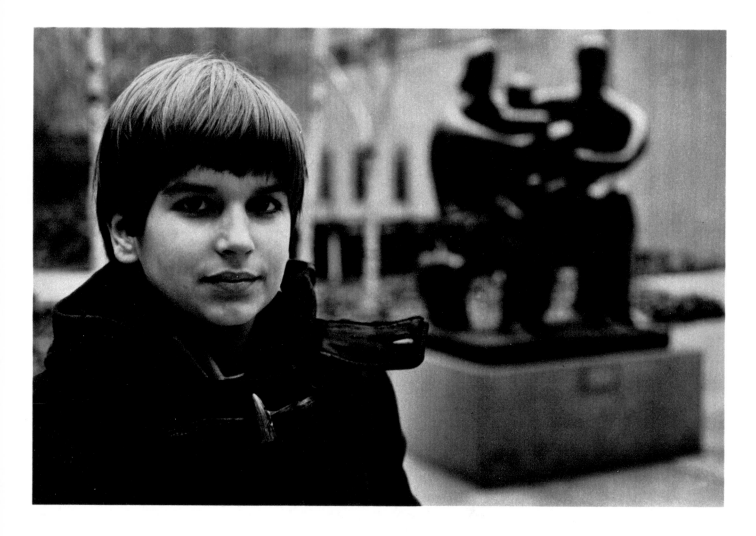

The outdoor portrait above was taken on an overcast, blustery afternoon in the sculpture garden of New York's Museum of Modern Art with a normal lens set at f/5.6 and focused on the boy, who was standing about four feet away. The sculpture in the background, less than 20 feet away, is reduced to a blur. Forced to focus on the foreground, even the smallest aperture on the lens could not have made both parts of that picture sharp.

Getting an outdoor portrait that preserves the sense of setting provided by sharp background details is difficult because the usual means of increasing depth of field cannot always be used. Even a very small aperture does not give sufficient background sharpness when the subject is close to the camera. And a wide-angle lens, for all its great depth of field, is no help because of the distortion it creates in nearby objects. To capture both the near and far

without distortion, the lens must focus on two distances at once. This can be done with a split-field close-up lens —one half is a supplementary lens that puts nearby objects in focus, while the other half is either plain, flat glass or simply empty. This half-lens, mounted as shown opposite, alters the focus in half the view, enabling the photographer to keep his subject sharp in that half while the background remains sharp in the other, unaffected half.

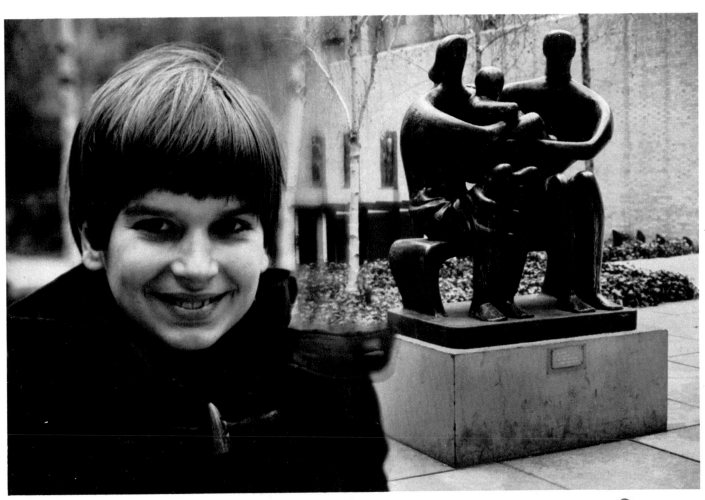

To get the clear images above, the photographer placed the split-field close-up attachment (right) over one side of his lens. He focused on the sculpture in the unaltered right half of the scene. He then had the boy move forward and back until his image, seen through the close-up side, was also in focus. That the lens-plus-attachment actually focused on two different planes at once is revealed by the birch trees in the background, which are blurred to the left of center but sharp to the right.

Wide Angles, Distortion-Free, with a Special Lens and Camera

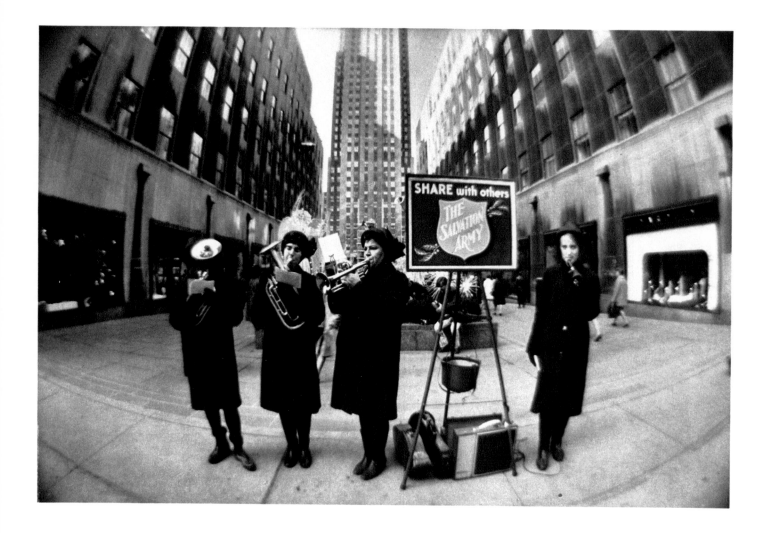

The "barrel distortion" flaw found in many extreme-wide-angle lenses on 35mm cameras—it makes horizontal and vertical lines bend in at the picture edges *(above)*—is eliminated by using an unusual lens whose design was cranked out with the aid of an electronic computer by Zeiss designers Fritz Köber and Erhard Glatzel. It provides a 15mm lens, the Hologon, that covers a 110° angle of view with practically no distortion *(opposite)*, bending light rays uniformly no matter how far from the center of the scene they originate.

For this wide-angle uniformity, the designers of the Hologon lens had to allow for some strange characteristics. The rear lens element is so thick and sharply curved that it must be positioned less than ⅕ inch from the film, and the only camera the lens will fit is one made specially for it, the Ultrawide.

The middle of the lens—where an adjustable diaphragm normally goes—is completely taken up by the center element. So there is no diaphragm; the lens is built to provide an aperture of f/8, and exposure is varied only by changing shutter speed or film. There is no focusing adjustment either, because the great depth of field keeps everything in the photograph sharp from 20 inches to infinity.

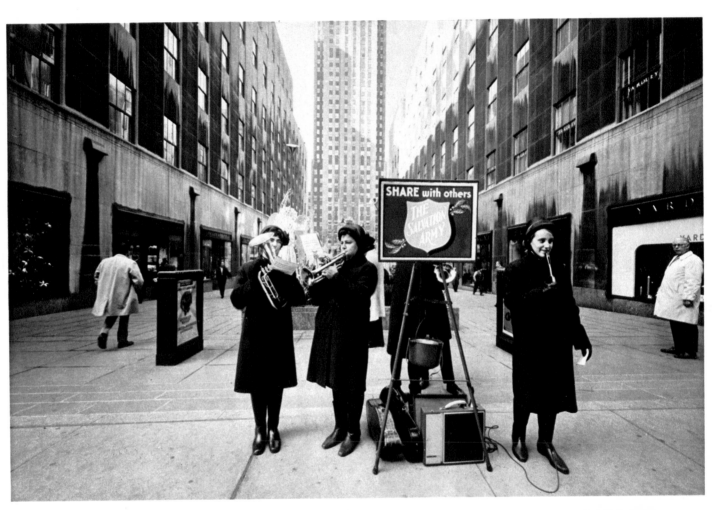

◀ *Not only the Salvation Army musicians but the skyscrapers surrounding them in the narrow Channel Gardens (opposite) of New York's Rockefeller Center can be brought into one 35mm picture by an 18mm lens—its very short focal length covers an angle of view of 148°. But in doing so, it must bend light rays from the edges of the scene more than those from the center, and straight lines seem to curve inward.*

The picture above covers 110°—close to the angle of view shown opposite—but with scarcely any distortion. Only the man at the extreme right seems oddly stretched. This shot was made with the 15mm Hologon lens in the Ultrawide camera (right), which is so designed that the disproportionate bending of light rays from the edges is canceled out in the lens. Like most wide-angle lenses, however, it provides less illumination at the edges than in the center. The nonuniform exposure has little effect on black-and-white film; for color the effect can be compensated by a graduated neutral density filter whose density becomes progressively greater toward the center.

A Picture Lit by a Match

Even when the only light available is the flare of a match, it is still possible to get a clear picture with a low-light-level camera system *(below),* made by Singer Librascope. Using techniques originally developed for the United States forces in Vietnam, it has been used for night surveillance there and for police stakeouts across the country.

The heart of this complicated device is an image-intensifier tube. Its front end is a light-sensitive surface, somewhat like the one in a television camera tube, that converts the light energy into electrons. Its rear end is a screen that converts electrons back into light. In between are amplifying circuits to make the light generated at the rear 7,500 times stronger than the light coming in at the front.

The system employs two intensifiers working in sequence behind a lens with a very long focal length—300mm or 500mm. The image on the rearmost screen is relayed by a second lens system to an ordinary 35mm camera. The combined light gathering power of all this apparatus is equivalent to an aperture of f/.2; the light has been magnified more than 10,000 times, enough to make visible people 400 feet away on a moonless night. Its cost: about $8,000.

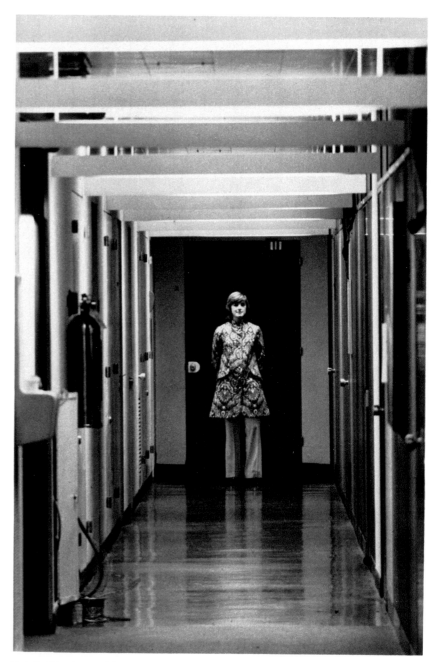

In the low-light-level system, which is 25 inches long and weighs 25 pounds, the largest section is the light-collecting lens. At center is the electronic gear that amplifies the light, while the adjoining relay lens passes it to the camera.

To take this picture with a standard Nikon with a 300mm f/4.5 lens, every light in the corridor had to be turned on for the two-second exposure. In all three pictures shown here the girl was 168 feet from the camera and the film was ASA 400.

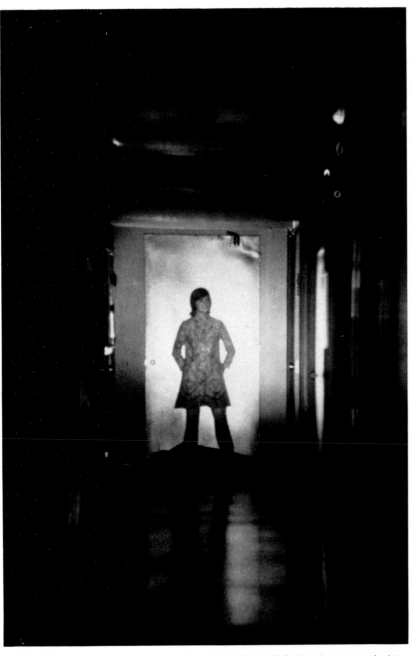

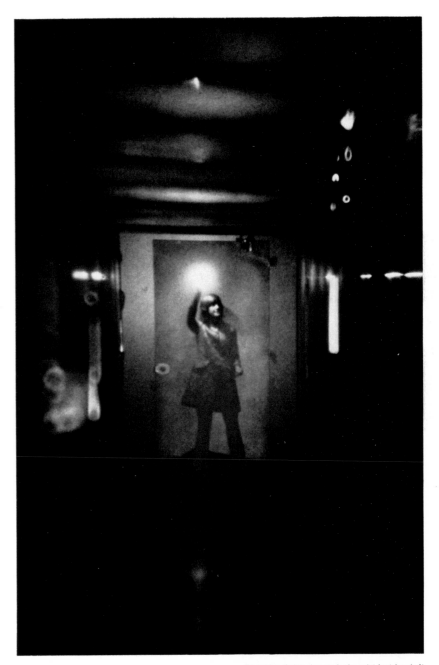

Using the low-light-level system attached to a 35mm camera, the girl is photographed at 1/30 second with every light in the corridor off. The only illumination is the beam from a flashlight shining on the girl from a nearby doorway.

Only the lighted match the girl holds aloft illuminated this picture also taken at 1/30 second with the low-light-level camera system. Every other light source was extinguished; even the glass above the doors was blacked out.

Adapting for High and Low Views

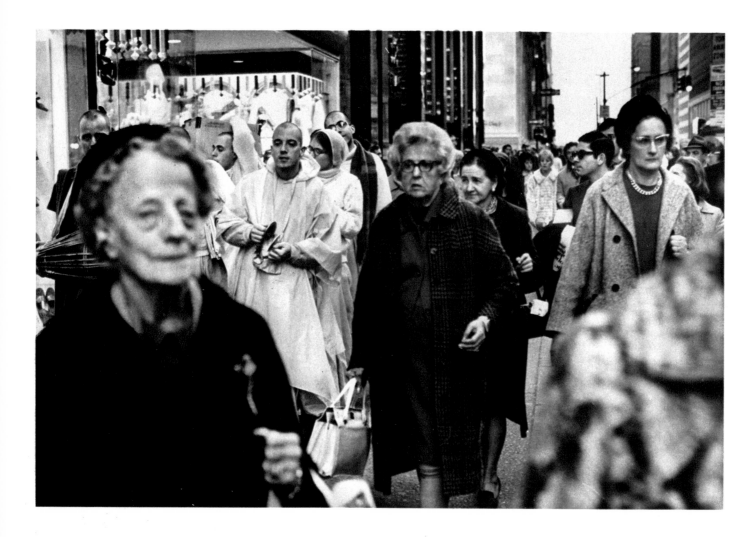

When shooting in a crowd—whether at a sporting event, at a parade or merely on a busy street—the photographer often finds himself unable to get an unobstructed view of his subject. A vantage point above the activity is the ideal solution, but it is not always available. In that case, there is another option: the photographer can simply hold his camera up at arm's length and shoot over the heads of the crowd.

Certain cameras lend themselves to this procedure because of their viewing systems. Thus, although a photographer working with a rangefinder camera can only aim in the general direction of his subject and shoot blind in such a situation, he is at no disadvantage if he has a twin-lens reflex: its ground-glass viewer enables him to hold the camera overhead, upside down, and see the picture he is taking. Most single-lens-reflex cameras can be easily adapted to work in much the same way. On some of these cameras, the ground-glass focusing screen remains locked in place when the prism is removed and can be used as a viewer just like that on a twin-lens reflex. On other SLRs, the prism and ground glass come off together. In that case, a special attachment called a waist-level viewer—simply a ground glass with pop-up metal sides which serve as light shields *(opposite)*—can be slipped into place to serve the same purpose.

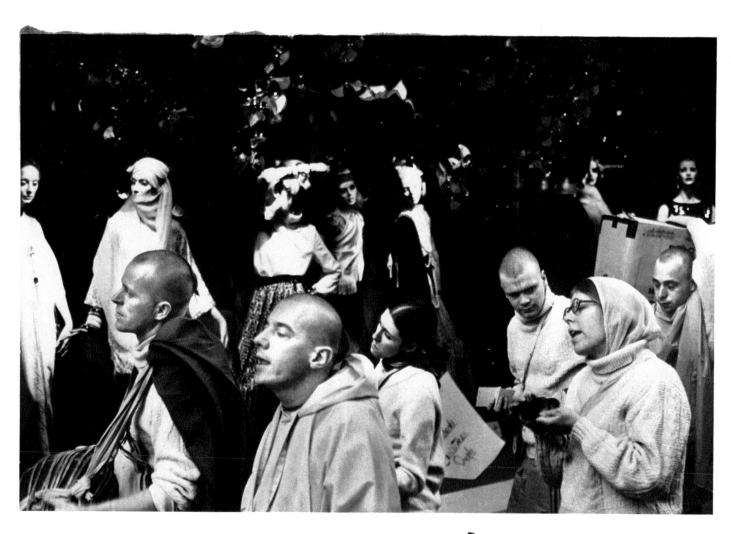

In the photograph opposite, the exotic group of ascetics at left is nearly lost among the more ordinary passersby. The photographer could not halt the pedestrians in order to shoot the group alone. To compose and focus the clear view above, he put on the accessory waist-level viewer shown at right, which made the viewing screen visible with the camera held an arm's length away. He moved out to the curb to avoid being jostled, raised his camera overhead, then looked up into the ground glass to see—and shoot—over the intervening crowd.

Making a Camera Shoot Sideways

People who suddenly discover that they are being photographed almost always freeze up—and the opportunity for a natural picture is lost. One way around this problem is a device *(below)* that enables the photographer to take a picture of a person to one side of him while he aims a camera straight ahead. The attachment has a false glass front so that it appears to be merely an extension of the lens. But inside the barrel is a mirror placed at a 45° angle to turn the field of view to one side. With an easy rotation of the attachment, the photographer can also see up or down —all while his lens seems to be pointed at other subjects. ☐

Believing the camera is not trained on them, the people at right are at their most natural. The attachment that catches them this way is the spiratone Circo-Mirrotach, made to be attached to long-focal-length lenses (100mm or longer), primarily on single-lens-reflex cameras (above). The Circo-Mirrotach picks up images through a mirror that enables the photographer to shoot down (top) or sideways (bottom), but which reverses right and left in the picture.

Problems of the Professional 3

A Gadgeteer's Exploits 72

The Experts' Ingenuity 82

A Ghostly View of a Live Concert 84

Switching Ordinary Equipment to Special Tasks 86

Totaling Up a Teacher's Workday 88

A Polite Way to Make People Vanish 90

"Profit by My Mistakes" 92

The newly completed Time & Life Building in mid-Manhattan seems to burst skyward like a song of pure technology (opposite), yet the picture was taken with aged, jury-rigged equipment. Yale Joel used a 75-year-old view camera with an extreme wide-angle lens, and held it out over the corner of the building with a 15-foot pole. The shutter was designed to be tripped by air pressure from a rubber bulb, but the bulb could not transmit enough pressure at that distance—and so he replaced it with an ordinary bicycle pump. While Joel (foreground, right) supervised the aiming of the camera, an assistant, at the base of the pole, operated the pump and snapped this arresting view.

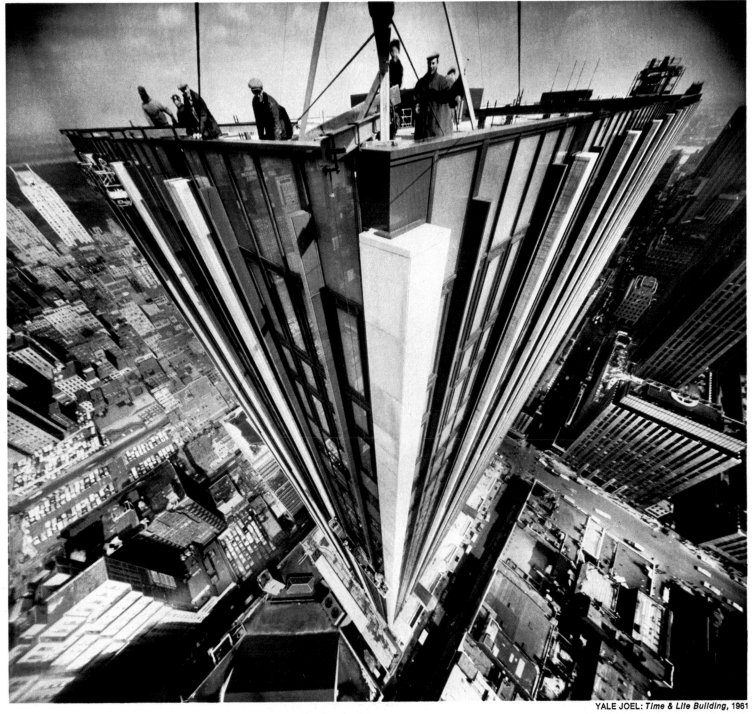

YALE JOEL: *Time & Life Building*, 1961

A Gadgeteer's Exploits

On the following pages, Al Schneider, head of the Equipment Section of the LIFE Photo Lab, discusses some of the special gear that he has built to solve photographers' problems. Beginning on page 92, LIFE photographer Mark Kauffman recounts some of the harrowing—but instructive—moments of his career:

Photographers continue to startle me with their requests for special rigs to make some kind of unusual picture. They have asked the Photo Equipment Department to build everything from lighting equipment that would illuminate an entire stadium—for a panoramic view of a football game at night—to a sparkproofed camera that, without any remote controls, would automatically photograph astronauts just as they entered their space capsule. Usually the solution to the problem turns out to be so simple it's almost funny; when Yale Joel asked for a compressed-air supply to work the shutter of a camera dangling from a boom [*preceding page*], a bicycle pump filled the bill. And then there is the $1.75 switch that makes stunning photographs of motion; it depicts action in two different ways in a single photograph—providing the blurred effect of a time-exposure as well as the motion-arresting effect of strobe.

Joe Scherschel raised that problem. He had been assigned to cover the beginnings of commercial Boeing 707 flights at Kennedy Airport in New York. He wanted to get a picture of the plane as it took off at night, and he could not decide between a stop-action picture with strobe and a time exposure that would show the streaks of the jet's lights. As he talked, it became clear that the best picture would show both views.

The solution was a common kind of switch having a very long name: a double-pole double-throw momentary contact switch with an OFF position in the center. Set one way, it could feed power to the camera; set the other way it could feed power to a strobe [*diagram opposite, bottom right*]. Joe took the picture [*opposite, left*] with a view camera whose shutter was tripped by a solenoid—an electromagnet that pushed a piston against the shutter button. The shutter was set on BULB so that it would stay open as long as the piston pushed. When he threw the switch into its forward position, electric current activated the solenoid and held the shutter open, so that the film recorded time-exposure streaks from the lights of the plane. When he threw the switch into its back position, the strobe was fired. At the same time, the solenoid circuit was broken, allowing the shutter to close—but not before the strobe-lit jet registered on the film. In fact, the view camera's large, leaf-type shutter closed so slowly that it was still partly open after the flash died out, and, in the picture, streaks of the plane's lights continue on past the strobe image. The editors of LIFE liked this effect and ran the photograph. But nowadays, for this technique, we use a camera with a fast-closing focal-plane shutter,

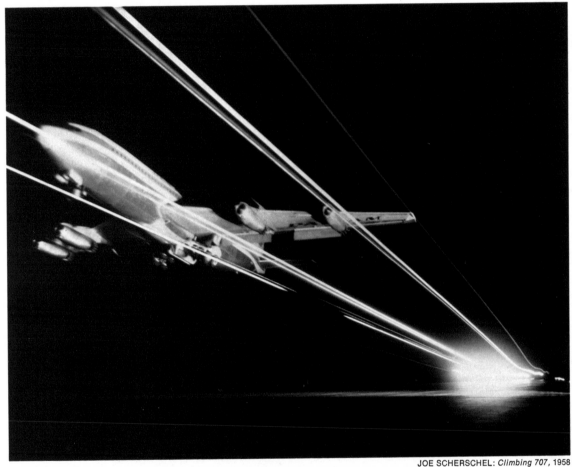

JOE SCHERSCHEL: *Climbing 707*, 1958

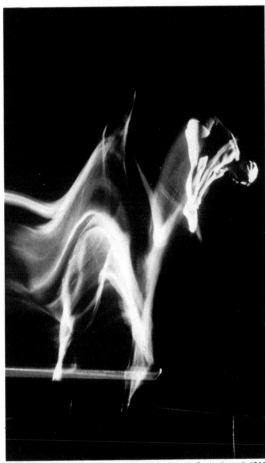

TONY TRIOLO: *Off the Springboard*, 1963

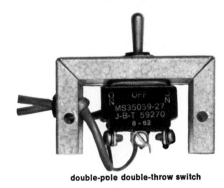

double-pole double-throw switch

The "double-pole double-throw momentary contact" switch at left is designed to create two versions of motion in a single photograph —time-exposure streaks or blurs, and a sharp, motion-freezing image. As diagramed at right, it controls both an electrically operated camera and a strobe unit. As long as its handle is turned to connect the terminals to its left, the switch holds a camera's shutter open; when flicked past the center (OFF) position over to the right-hand terminals, it stops holding the shutter open and fires an action-stopping strobe just before the shutter has had time to close. In the picture of the jet airliner above, the streaks from the landing lights continue on past the strobe image because the leaf-type shutter of the view camera closed slowly. A camera with a fast-closing focal-plane shutter was used for the picture of the jackknifing girl, so that the strobe image was the very last thing that the film registered.

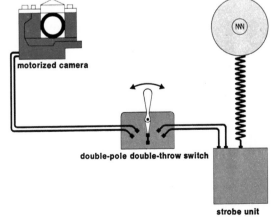

motorized camera

double-pole double-throw switch

strobe unit

73

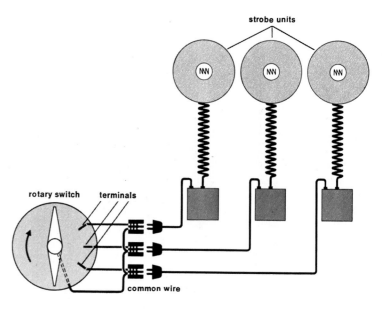

so that the blurred time-exposure portion of the picture comes to an abrupt end as soon as the strobe is fired [*preceding page, right*].

Many of the gadgets that we have built over the years are intended to give photographers more flexibility with lights, particularly strobe. Often there is a need for a strobe that flashes repeatedly to produce multiple images of a golfer's swing or a ballet dancer's leap in a single picture. Some strobes are specially designed to work that way—but they are bulky, heavy and very expensive. And while they give out enough light for good black-and-white pictures, they often are not powerful enough for color. On the other hand, regular strobe units give out plenty of light, but can seldom fire at a rapid rate. The answer to the problem is a switching system that triggers a whole battery of ordinary, powerful strobes one after the other. The device that we came up with does the switching electronically; it has no moving parts—just vacuum tubes, capacitors and so forth. Ten strobe units can be plugged into it, and they can be triggered sequentially at any rate from one flash every second to 12 per second.

The electronic sequence switch is easy to control, and it fires the strobes at very regular intervals. But if perfect spacing of the flashes is not essential, a manual system can operate strobes in sequence. Several strobe units—of any size—can be controlled with a gadget called a single-pole rotary switch, which can be bought at any radio supply store for about $2.00. Wires from the individual strobe units are attached to the terminals of the switch [*diagram, right*] and the lights are fired off in rapid succession when the rotary switch is given a quick twist by hand.

Sometimes photographers want to create a sense of motion where there is none. In principle, this is a cinch: just pan the camera while the shutter is open. But it's not so easy to pan a camera smoothly and at an even rate. Getting a really good illusion of motion requires a tripod with a motor-driven head. And this was exactly the equipment that Yale Joel requested some years ago when he wanted to use the panning technique to get some out-of-the-ordinary pictures of motorcycles. I told him that a motorized tripod would be very expensive, since it had to be especially machined and geared. Joel nodded understandingly and disappeared.

A few days later he showed up with the necessary equipment—an ungainly rig that he had put together with a few dollars' worth of old parts [*diagram, opposite page*]. He had dug up an old sewing machine motor from somewhere and fixed it so it would turn a belt that slowly rotated a tripod head. It looked like a real Rube Goldberg contraption, but it worked like a charm.

To get one photograph, Joel brought a motorcycle to the studio and had a model sit on it. He told her to lean forward as if she were roaring along a road, but of course she wasn't going anywhere. (In fact, the motorcycle was

Several strobe units can be fired in rapid sequence if they are wired into an ordinary rotary switch as diagramed above. A common wire connects one half of each strobe circuit to the movable part of the switch. The other half of each strobe circuit goes to a separate terminal on the switch. The photographer simply twists the switch, and as it turns it completes one circuit after another, firing one strobe after another to produce multiple images of a moving subject. Any number of lights can be used: the switch box below, used by LIFE photographers, can handle 17 strobe units (the camera sync wiring plugs into the eighteenth socket).

switch box

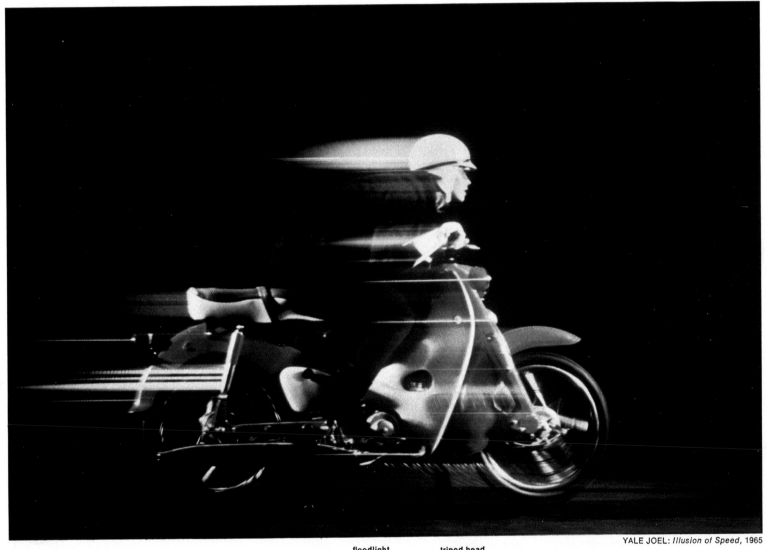

YALE JOEL: *Illusion of Speed*, 1965

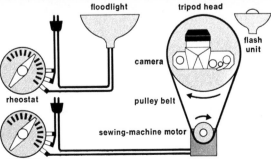

floodlight tripod head

flash
unit

camera

rheostat

pulley belt

rheostat sewing-machine motor

The girl who seems to be racing along on her
motorcycle in the picture above was not actually
moving—but the camera was. Yale Joel used
the rig diagramed at left to get the photograph.
A rheostat, connected to the sewing-machine
motor, allowed him to control its speed as it
turned the tripod head on which his camera was
mounted. The camera was pointed behind
the motorcycle when he began the time
exposure. When the panning camera was aimed
right at the girl, he dimmed the floodlight with
a second rheostat, fired a flash bulb for a
bright stop-action image, and closed the shutter.

resting on its parking stand—although that did not show when the picture was printed in LIFE.) Then he went to work. First he switched on his motor. The camera, which had been aimed to one side of the girl, slowly panned toward her. He opened the shutter, and it stayed open because it was set on BULB, producing a blur of illusory movement on the film. Just when the camera was pointed straight at the model, Joel dimmed the lights, set off a flash bulb and immediately closed the shutter. The bright flash registered the girl's image strongly on the film and froze her motion—which was really the camera's motion. The nicest touch of the picture is the whirling of the motorcycle's front wheel. Since the parking stand lifted the front wheel off the ground, Joel was able to give it a good spin for verisimilitude before he began his complicated exposure.

Only slightly less strange-looking than Joel's sewing-machine-motor contraption was an essential piece of equipment improvised to cover rocket launchings at Cape Kennedy. The National Aeronautics and Space Administration has a rule—a necessary one—that any electrically operated camera or switch in the launch area must be completely sealed in a container filled with nitrogen gas. Unlike air, nitrogen does not support combustion, ensuring that an electrical spark will not set fire to the volatile rocket fuel. But, of course, a nitrogen-filled container for a camera would be very expensive if it had to be designed and built from scratch—which is what NASA had done for its own cameras. We found a short-cut. We took a clear plastic camera housing, ordinarily used for underwater photography, and equipped it with intake and exhaust valves so that air could be pumped out and nitrogen gas could be pumped in [*right*]. Perhaps it isn't the most beautiful article of equipment in the world, but it is perfectly airtight and safe.

We used a similar, slightly larger housing for the launch of the Apollo 11 moon rocket in 1969. The editors had asked for photographs of astronauts Armstrong, Aldrin and Collins just as they were entering the capsule on top of the rocket. After months of negotiation and paperwork, NASA reluctantly gave permission to mount a nitrogen-filled housing along the steel walkway that led from the gantry tower to the capsule. However, for safety reasons, no wire or radio remote control could be set up to operate the motorized camera, so a NASA technician was enlisted to switch it on when the astronauts approached the walkway. But there was another problem. Armstrong and Aldrin were scheduled to enter the capsule first; five minutes later, after they were buckled into their seats, Collins would arrive. This meant that if the technician threw the switch and started the camera snapping pictures of the first two astronauts at the rate of two per second, all the film would be gone by the time Collins arrived.

Once again, there was a simple solution: a small, motor-driven timer. It

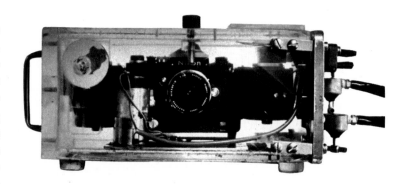

Because of the danger of a spark setting fire to the highly flammable rocket fuels at Cape Kennedy, all electrically operated cameras covering a space launch must be enclosed in a nitrogen atmosphere, which will not support combustion. Rather than design and build a brand-new housing for their camera, the LIFE Photo Lab adapted a plexiglass housing formerly used for underwater photography, on the sensible assumption that if it kept water out, it would keep gas in. Two valves were inserted in the side of the housing so that air could be exhausted and nitrogen pumped in. The cylinder at the front of the housing is a heavy-duty battery to drive the 250-exposure motorized Nikon. The circular bolt at the upper left-hand corner is used for mounting the camera housing.

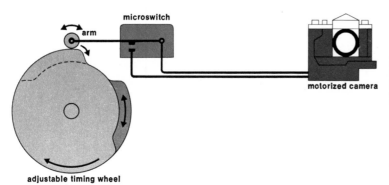

microswitch

arm

motorized camera

adjustable timing wheel

automatic three-camera timer

The timer shown here is driven by a continuously operating electric motor and can automatically trigger a motorized camera at regular intervals, minutes or hours apart. Essentially the timer consists of a small switch whose arm is pressed against a steadily turning wheel (diagram, top). When the arm of the switch dips into a notch on the revolving wheel, two contacts in the switch close, and electrical current flows in the circuit that operates the camera. The wheel is really two similarly shaped disks—called cams —sandwiched together. By manually rotating one of the cams while keeping the other still, the width of the notch can be adjusted, changing the length of time that the camera will shoot. The frequency at which the camera shoots depends upon the preset speed of the revolving cams. The timer shown in the photograph directly above has three sets of wheels and switches, enabling it to control three cameras. Ralph Morse employed it to regulate the photographic coverage of the activities of aquanauts in Sealab I (at right, above), a submergible Navy research vessel constructed to explore the problems of living under water for extended periods.

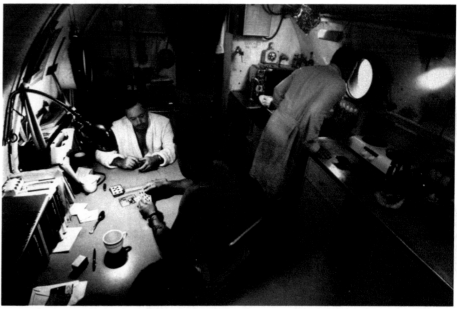

was installed in the housing along with the camera and programmed to fit the circumstances. As soon as the technician threw the switch, the timer went into action. Its electric-clock motor turned a cam that closed a circuit and started the camera shooting rapidly. After a few seconds, the timer switched the camera off; then five minutes later it switched it on again—exactly when Armstrong started to cross the walkway—and the camera shot the rest of the roll. Luckily for us, astronauts are very punctual.

Timers, even simple, inexpensive ones, are very useful in photography. When a motorized camera is set for continuous shooting, the timer can start or stop the shooting at predetermined intervals, as one did for the moon-launch pictures. If the camera is set for single shots, the timer can trip the shutter for individual pictures at almost any rate; for example, to get a time-lapse sequence of pictures showing a flower bursting into bloom, a motorized camera can be set in position and connected to a timer that will trigger it every few minutes, completely automatically. There are dozens of timers on the market, as a glance at any electronics supply catalogue will show. They range from the kind often used to turn house lights on and off to deter burglars, some of which cost less than $10, to very expensive ones meant to control complicated manufacturing processes. Our timers cost about $30 each, and one of their advantages is that they can regulate several independent operations at once. Ralph Morse called on this ability when he was doing a story on Sealab I in 1964.

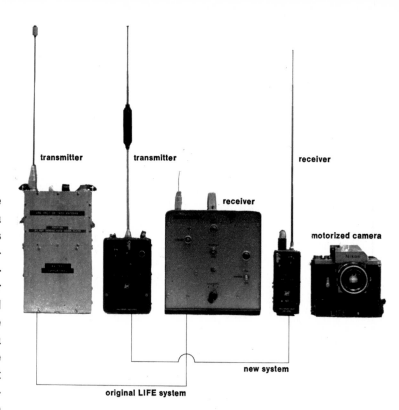

transmitter transmitter receiver

receiver

motorized camera

new system

original LIFE system

The original LIFE radio system, a pioneering tool for remote control of strobe lights or a motorized camera (above, right), has been supplemented by a more compact system, as the side-by-side comparison above suggests. The old transmitter and receiver together weigh 15 pounds and have a maximum range of one-and-a-half miles. The new, commercially available radio system weighs a total of three-and-a-half pounds and permits remote control from as far as three miles away. Made by Jacobson Photographic Instruments of California, it can transmit and receive signals on five different channels—a valuable feature if there are other transmitters in the vicinity.

Sealab I was a submergible structure that was lowered 192 feet below the surface of the ocean off Bermuda. The United States Navy had built it for a research program to see if men could live and work under water. Morse was not allowed to go down with the aquanauts; nor could he operate the cameras by remote control, since there was no electric-wire contact with the surface, and radios do not work under water. So he substituted a timer for himself. He mounted three motorized cameras inside Sealab—one trained on the hatchway, one on the working area and one on the bunkroom. The aquanauts were instructed to switch a camera on whenever they entered a particular area and switch it off when they left, in order to save film. Once started, each camera automatically proceeded to shoot at its own distinct pace, because the cameras were wired to the timer, which had three separate cams [*preceding page*] to trigger each camera at a different rate. When the hatchway camera was turned on, it took a picture every 10 minutes, the workroom camera one every 20 minutes, and the bunkroom camera one about every hour. As it turned out, his carefully orchestrated sequences did a fine job of documenting the activities of the aquanauts.

That assignment might have been muffed if Morse had not remembered one small detail. The atmosphere inside Sealab I was at a much higher pressure than that at sea level. It was so high that it might have caused the cameras' lens elements to implode, because the airtight lens barrels contained air at ordinary pressure. This disaster was averted by drilling tiny holes in the lens barrels, permitting pressure inside and outside to be equalized as Sealab was lowered into the depths.

Not all problems can be solved so simply, however. When strobe flash units first came into wide use in the 1950s, for instance, there was no way to trigger the lights without being tied to them by electric wires. The "sync cord," which sets off the strobe when the shutter is tripped, was often a bother. To cover a big dance, a photographer had to string sync cords between his camera and the strobes mounted around the ballroom. The wire linkage usually took a couple of days to set up, and it restricted the photographer's movements when he was shooting. So, in 1955, we set out to replace the wire with radio. Two units were needed—a transmitter, plugged into the camera and carried by the photographer, and a receiver that was plugged into the lights. When the photographer tripped the shutter, the radio transmitter would send a signal to the receiver, instantaneously setting off the strobes. We hired an electronics specialist to help us design and build the system [*right*]—a process that took two long years. Sometimes the radio receiver that triggered the lights was set off by electrical interference from water coolers or cash registers. But when all the bugs were worked out, the radio linkage gave LIFE photographers a tremendous advantage in covering large

interior scenes like political conventions or basketball games. (Today, of course, similar gear, factory made, is widely used.)

The radio remote control proved very useful outdoors, too. When the receiver was attached to a motorized camera instead of to lights, the photographer could take pictures from a mile or more away just by pressing a button on the transmitter. In fact, one of the first jobs for the radio system was at a sports car race in Wisconsin. Joe Scherschel mounted a camera on the hood of one of the cars and operated it by radio from a hillside where he could see the whole race. Action pictures like that had been taken before by having the driver operate the camera with a cable release—but at tense moments in the race, when drama was at a peak, the driver usually had other things on his mind than tripping a shutter.

But an attempt to use radio control in a similar situation almost ended in disaster. Jerry Cooke wanted to shoot a new kind of picture of a harness race for SPORTS ILLUSTRATED. Since a horse pulls a sulky in a harness race —instead of carrying a jockey in the saddle—there was an obvious opportunity to use radio remote control. The track officials reluctantly gave permission to mount a motorized camera and radio receiver on a sulky, facing backwards to show the trailing drivers and horses as they went around the course. The officials were nervous about the idea because these were real races with a lot of money at stake, and thousands of bettors were going to be very angry if the equipment affected the outcome.

Well, Jerry Cooke is a very calm guy, impossible to fluster. As one race got under way, we were standing in the infield of the track, and he was watching through binoculars and operating the transmitter to get photographs of the action. I heard him say, "Okay, they're going around the curve . . . they're bunching up very nicely . . . we're getting some good pictures . . . oh my God, the camera is falling off." All in the same calm tone of voice. I had visions of disaster if the equipment fell into the path of the horses behind, and maybe some violent mob action after that. But we were saved by the skin of our teeth. I had wrapped a piece of baling wire around the body of the camera just as a precaution. It held, and the sulky finished the race with the camera dangling behind.

LIFE photographers still use wires for remote control of their motorized cameras where radio is prohibited. In fact, the "direct-wire" system can be given a lot more flexibility by building a gadget that allows the wire between the photographer and camera to be very long. Normally, a motorized camera is operated from a distance by pressing a button on a battery pack, which then sends electricity to run the camera motor. In most cases, the wire from the battery to the camera should be no longer than about 500 feet; beyond this length, the losses in the wire will weaken the current so much that the

camera motor will not function. But there is a way around this difficulty: use two batteries. One is placed with the camera, and the other with the photographer. The battery attached to the camera runs the motor and is turned on and off by a relay, an electrically operated switch [*right*]. The signal activating the relay comes from the battery near the photographer, and since the relay needs only a very weak signal to work it, the photographer and the second battery can be as far as two miles away. This is a pretty substantial improvement, considering the relay costs only about $15.

Recently, Ralph Morse employed this system at Fort Sill, Oklahoma, for a story on an unusual junk-disposal technique. The Army is doing its bit to clean up our environment by using junked cars for target practice at its artillery range. While the artillerymen learn accuracy, the old cars are blown to smithereens by the exploding shells. Morse wanted to place his three cameras fairly close to the cars to get dramatic views of their destruction, but he could not go into the target area, of course. Nor could he use radio to operate the cameras, for the Army had so many radios in the vicinity that they interfered with the signal of Morse's transmitter. So he strung a mile and a half of wire between his vantage point and the target zone, and sat there pressing a button on his control whenever a shell headed out to explode one of the cars [*opposite*]—comfortably getting a series of pictures that, without ingenious thinking, could never have been made. *Al Schneider* ☐

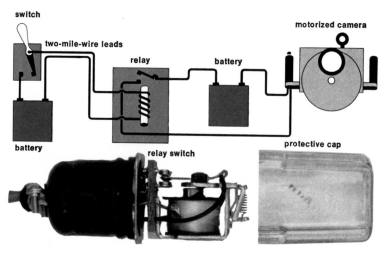

Long-distance control of a motorized camera is made possible by a relay switch—shown above with its protective plastic cap removed—which closes a contact when electric current activates its electromagnet (diagram, top). The use of the relay eliminates problems caused by voltage loss in a long-wire connection, permitting operation of a camera from as far as two miles away. When the photographer throws a switch, the battery beside him sends a current to the relay. Even though this signal is weakened by resistance in the long wire, the relay is so sensitive that it instantly closes a circuit that connects a battery next to the camera. Current from this battery, suffering no losses from any long-wire connection, is available at full strength to run the motorized camera.

Al Schneider has been the Equipment Section head of the LIFE Photo Lab since 1956. In addition to building novel devices, he presides over an inventory of photographic gear that includes hundreds of camera bodies, 150 Ascor 800-watt-second strobe units, and a variety of lenses ranging from a 7.5-ounce fisheye to a 60-pound, nine-foot 2,000mm.

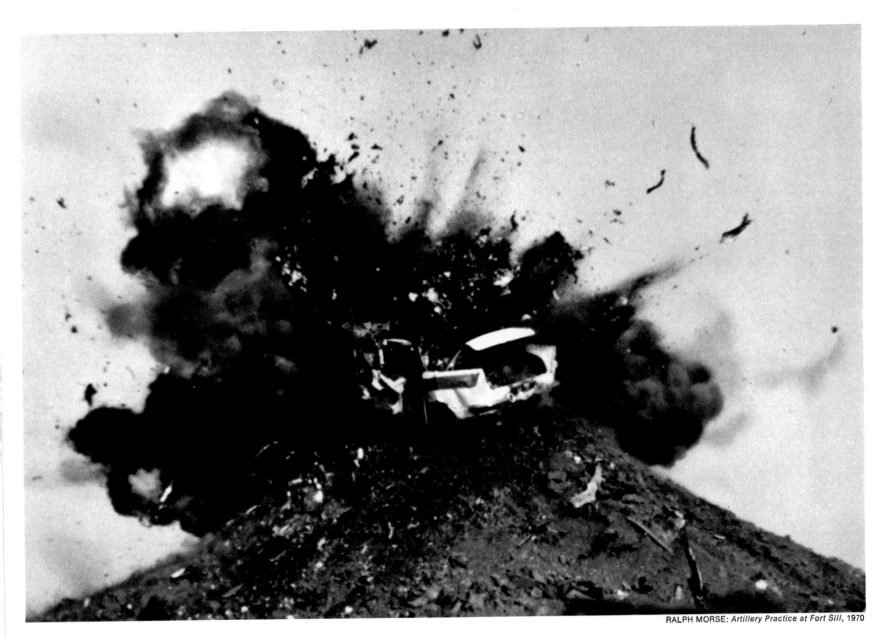

RALPH MORSE: *Artillery Practice at Fort Sill*, 1970

*Striking savagely from the sky, an artillery shell
demolishes an old car during target practice at
Fort Sill, Oklahoma. The rapid-shooting Hulcher
camera that caught this paroxysm of exploding
metal was only 75 yards from the target—but the
photographer, Ralph Morse, was safely located
a mile and a half away, operating the camera by
the relay system shown on the opposite page.*

A Ghostly View of a Live Concert

Necessity proved to be the mother of invention when Gerald Jacobson was covering a rock concert at Brandeis University in 1968. Assigned by a book publisher to photograph a group called The Blues Project, he had to select his vantage point beforehand, for he would be unable to move once the audience packed into the gymnasium. He decided not to stand at the back of the gym because he would be too far from the performers, and he did not want to shoot from directly in front of the temporary stage since that would have required him to shoot upward at a sharp angle, distorting the pictures. The only other alternative was to stand at the side of the stage.

However, when the concert got under way, it appeared that his choice was a mistake. From his position at the side he was shooting into the stage lights; furthermore, the angle offered mostly profiles and back-of-the-head views, neither of which appealed to him. Then he saw the solution. The lights—two enormous spots with mirrored reflectors—were mounted close together at the back of the gymnasium and were casting very sharp shadows of the performers on the backdrop. All the ingredients for a stunning picture were there: the lettered curtain indicating that this was a university concert, the gleaming, dominant shapes of the sound equipment, and the shadows—insubstantial and yet larger than life. By upsetting the familiar make-up of reality, he got a composition that demands a second and third look.

Only one musician (left) got his face into this picture; the others are represented by their shadows, cast by spotlights. The photograph was taken with a Leica equipped with a 28mm lens, and was exposed at 1/60 second at f/5.6. To emphasize the supernatural quality of the scene, high-contrast paper was used in printing.

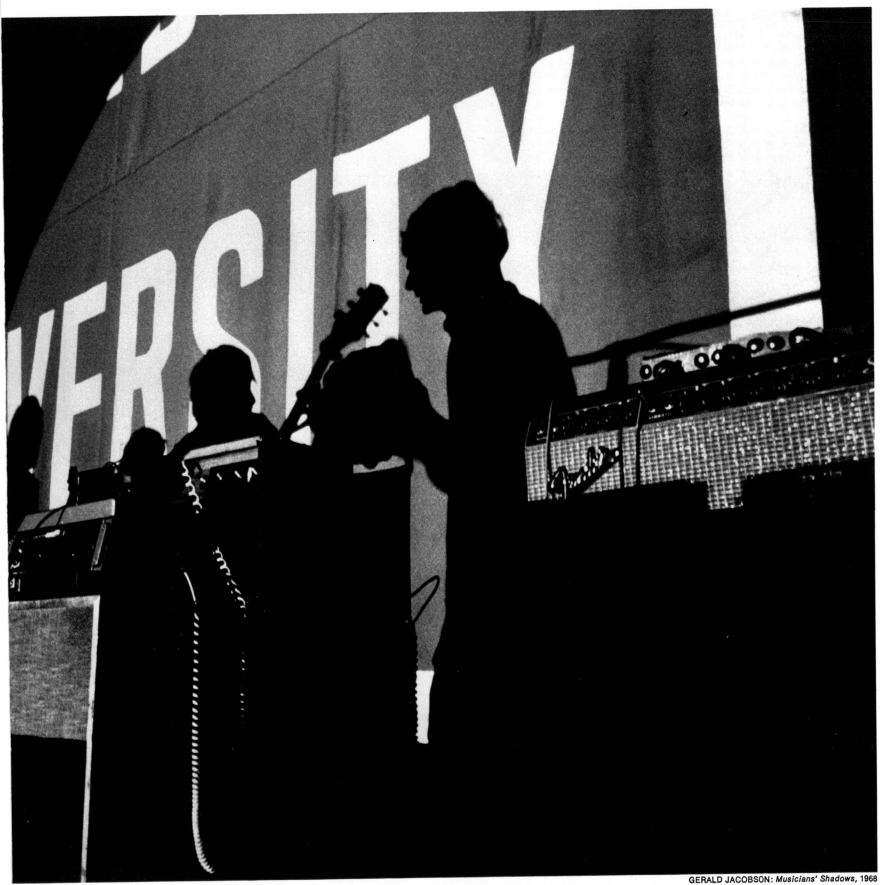

GERALD JACOBSON: *Musicians' Shadows,* 1968

mask used resulting film image

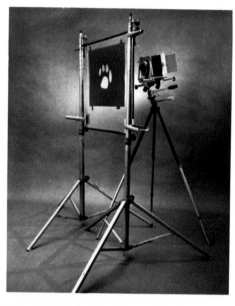

Totaling Up a Teacher's Workday

For a story on the nation's strained educational system, LIFE photographer Ralph Morse set his sights on a picture that flew in the face of good sense. He felt that the best way to illustrate the hectic job of a fifth-grade teacher was to show the teacher in several different places at once. This would have been fairly easy to do through multiple exposures if the teacher were in an empty room, but it seemed completely impractical in a roomful of restless students, who could not easily be kept from moving in the picture.

But after laborious experimentation, Morse devised a technique that brought off the illusion *(opposite).* He aimed his camera through a pane of glass that was covered by a mask made of several sections of black paper. Each section was attached to the glass by its own piece of double-stick tape—allowing the sections to be removed and replaced independently. Without changing the camera position, he made six exposures, removing a different section of the mask every time *(left),* so that each exposure caught only the portion of the schoolroom uncovered by that particular section. In between exposures, the teacher walked from one place to another; her course had been determined when the mask was made.

Most of the children did not have to remain motionless throughout, since they figured only in the first exposure *(top left)* taken with the largest section of the mask removed. But a few children appeared in later exposures, and they had to stay perfectly still. In these crucial spots, Morse placed students who were hand-picked for patience —since the complicated composition required three long minutes to make.

The same teacher appears six times in this multiple exposure, made with a view camera equipped with a wide-angle lens. Mounted in front of the camera on floodlight stands was a pane of glass to hold the paper masks that covered different parts of the scene for each exposure. Tests showed that the best results were obtained if the glass was positioned four inches in front of the lens—equal to the focal length of the lens. To prevent ghost images —caused by reflections between the two surfaces of the glass—two identically shaped masks were used, one on the front of the pane and the other the back. The mask sections farthest from the camera had to be 1/16 inch larger to allow for bending of light by the glass.

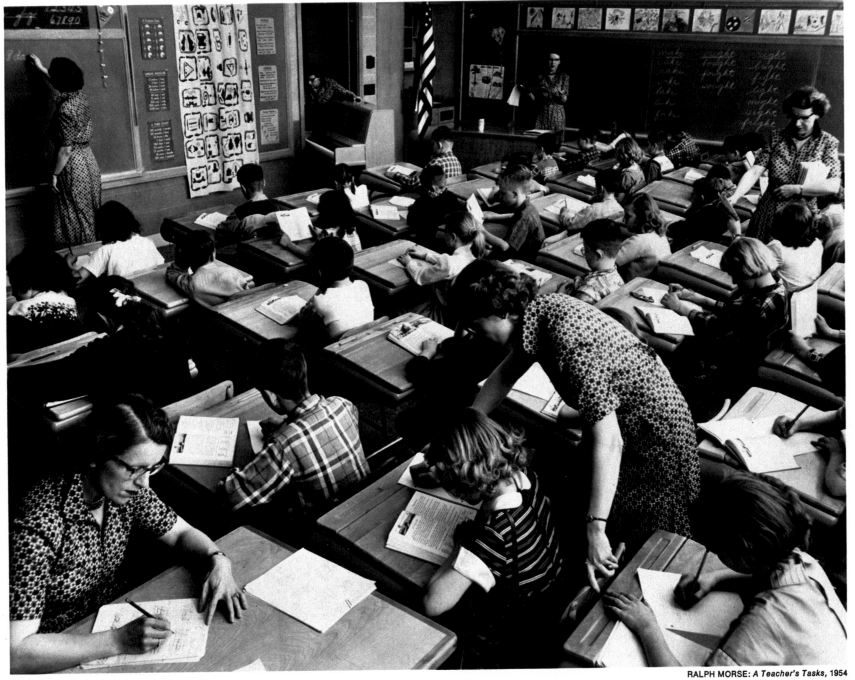

RALPH MORSE: *A Teacher's Tasks*, 1954

A Polite Way to Make People Vanish

Cathedrals, palaces and historic homes are favorite photographic subjects for the vacationer, but they pose one special difficulty: the photographer is not alone. Invariably other tourists are present and they will appear in the picture, adding a jarring, anachronistic note to the architectural splendors. Yet there is a way to erase the tourists, as if by magic. Evelyn Hofer used it for her photograph of the 1,000-year-old Baptistery in Florence *(opposite)*. Not a single person is in sight, even though the picture was taken at the peak of the tourist season, when hundreds of people were milling about in the building. They all have been eliminated by the simple tactic of making a very long time-exposure.

A long exposure was perfectly suited to Miss Hofer's purposes in any case. It allowed her to record the scene by the weak available light, without having to set up floodlights or resort to strobe or flash bulbs that might have given uneven lighting over such a large area. Also, an extra amount of exposure was required because she used a red filter to bring out the geometrical pattern of the two kinds of marble in the wall. Age had so darkened the white marble that it normally would have been hard to distinguish from the thin, decorative slabs of green marble; but a red filter —which blocks green light—turned the green slabs black and heightened the contrast in the wall. The combination of the filter and the dim light—plus her choice of a slow film—permitted her to keep the shutter open for 20 minutes. As a result, the moving people did not register on the film. However, she was not totally successful. One ghostlike streak can be seen in the lower left-hand corner of the picture. It was caused by a tourist who was apparently so transfixed by the architecture that he stayed in one spot several minutes. □

Passing crowds of tourists never show in a 20- ▶ minute exposure of the marble-lined Baptistery in Florence, taken with a 4 x 5 Linhof view camera mounted on a very steady tripod. Several factors made such a long exposure possible: the light coming through the opened entrance door was very dim; a red filter over the lens reduced the amount of light reaching the film by an amount equivalent to three or four f-stops; the aperture was set at a minimum opening of f/64; and the film was slow, ASA 64.

EVELYN HOFER: *Interior of Baptistery in Florence*, 1959

chair, for example) but less obvious ready at hand. And watch out for winkers; they can spoil your pictures too.

Too much light, remember, can be even worse than not enough light. Once I was doing a baseball story in Cuba (long ago when you could do baseball stories in Cuba), and made the mistake of leaving one of my cameras on a bench bordering the playing field. The lens was pointed up, right at the sun. The lens, acting just like a Boy Scout's magnifying glass, focused a bright, hot image of the sun onto the camera focal plane, where the cloth shutter covers the film. It burned a nice little hole right through the shutter so that light could reach the film underneath. All of the pictures taken with this camera had a bright white spot in the middle. I wasn't aware of it, of course, but when the film was shipped unprocessed to New York, I got a cable right away from Bill Sumits, then head of the LIFE darkroom. "YOU'VE GOT A HOLE IN SHUTTER OF ONE OF YOUR CAMERAS LEAVING SPOT ON FILM. MUST HAVE BEEN LEFT FACING SUN." When I got back to New York, I asked Sumits how he detected it so quickly. He said, "Made the same mistake years ago in Kansas."

Ever since then I've been careful to leave my cameras and film in the shade. Not only can the sun burn through a shutter, but the sun's heat can get at your film and change its color—sometimes it turns a sickly red, so bad that you can't even pretend you "wanted that red for effect." I guess the worst time I had with the sun was on an assignment in the Jordanian desert. I was covering director David Lean while he was filming the movie *Lawrence of Arabia*. I remember the star, Peter O'Toole, remarking, "There goes Kauffman playing the shade game again," while I scurried around trying to keep my cameras out of that blazing sun.

The *Lawrence of Arabia* cameramen let me keep my main supply of film in the only available air-conditioned van, which had been brought along to keep their movie film cool. Every day I took just what I thought I'd need for that day, and then the "shade game" would begin. I spent more time during the day finding some little shadow in which to park my equipment than I did taking pictures. Bringing my own umbrella with me would have saved me a lot of unnecessary trouble and worry. To top it off, I managed to forget another lesson, one I thought I had learned earlier in northern Minnesota in the dead of winter—keep your film warm as well as cool. As is the case in all deserts, the temperature drops drastically when the sun goes down; in Jordan it plunged from 120° at noon to 45° or lower at dusk. The cold, combined with the drop in humidity, produced lines of static electricity right across the film. So the lesson is: don't let your film get overheated or overcold, even if it means walking along a beach with an umbrella, or carrying rolls of film under your shirt in ski country.

Viki, Kauffman's most difficult living subject, was bathed daily by her psychologist "mother," Mrs. Keith J. Hayes (upper left), in an experiment designed to test the capacity for learning in a chimpanzee raised like a human child. After the morning tub, Viki would cavort around the bathroom before dressing.

One of the commonest mistakes many a photographer makes in shooting where there are crowds of people is to assume that he has an advantageous location, only to discover how wrong he is. In a stadium covering a boxing match, I was under the impression that I had the perfect spot for picture taking. I did, as long as the crowd remained seated. But during the dramatic high point of the fight the crowd naturally rose like a wave in front of me and I was left with stunning pictures of the backs of people's heads. I have learned that a handy piece of equipment in these situations is a small portable stepladder. Alfred Eisenstaedt, who stands all of five feet tall, has his own way of seeing over crowds. Unable to see clearly the inauguration of President Dwight D. Eisenhower in 1953, Eisie asked the girl reporter accompanying him to bend down. He then climbed up on her shoulders, and, as she straightened up, he snapped his pictures from his human perch. I'm six feet and weigh 185 pounds—I use a ladder.

Photographers can also commit errors in not giving their subjects a complete fill-in on what they want to do. I once narrowly escaped an onslaught by the beautiful but fiery actress Melina Mercouri just because I neglected to tell her all the details of my photographic mission. My assignment concerned a movie that starred several lovely actresses—including Miss Mercouri and Romy Schneider. I had shot Miss Mercouri first, and on the following day I started taking pictures of Miss Schneider. She proved a difficult subject, reluctant to pose. But after some experience photographing Hollywood actresses, I had had the foresight to bring along a well-chilled bottle of champagne. After a few sips, Romy became more animated and I took some lively pictures. Then trouble arose: Melina happened along and saw me with another actress—and the champagne. Her temper flaring, she all but flew at my eyes. It turned out that she assumed I hadn't liked the pictures I had made of her. I hurriedly explained that I was photographing *all* the actresses, not just her. If I had told her this at the outset, there wouldn't have been such an embarrassing scene.

But Melina was no problem at all compared to Viki. Viki was a chimpanzee; a Florida psychologist, Keith J. Hayes, and his wife had brought the chimp up just as parents would their own child, in a carefully controlled experiment to see how human a chimp can get. I was warned ahead of time that I must be very polite and understanding with the little beast, so as not to upset the experiment. It sounded like fun. Little did I realize that the chimp would have most of the fun.

At the Hayes's home, Viki met me at the door, took my hand and led me into the living room. As I chatted with the Hayeses, Viki sat on my lap. Slowly she pushed her long, bony finger up my nose. As I started to squirm away, Hayes cautioned me to let Viki do whatever she wanted. "We try to treat Viki exactly

like a child," he explained. Viki seemed to enjoy having her finger up my nose because she kept it there until I felt blood beginning to trickle down my nostril. I also began to sweat, whereupon Viki lost interest in the inside of my nose and turned her attention to my beaded, balding brow. She crawled up on my chest and started to lick my forehead. When she tired of that, she dropped to the floor, pulled off my shoes and clumped around the room in them. It was like that for four days. I ate with Viki and talked with her—in somewhat limited conversations since her vocabulary was confined to such words as "cup" and "mama." I even took her to a drive-in movie. She grew quite fond of me, but for my part I was happy to end the one-sided romance as soon as I had my pictures. My mistake was in assuming that such a subject would be easy to photograph. I've learned that *any* subject can turn out to be difficult to cover, and a photographer should be prepared for every imaginable hazard and inconvenience, even including the affectionate attentions of a chimpanzee.

Without doubt, the most unnecessary mistake photographers consistently make is neglecting to see a picture that is begging to be taken. If I have ever been guilty of that error I will not want to acknowledge it, even in jest. But I'll never forget one scene that another photographer almost ruined for me. We were in the locker room of the old Brooklyn Dodgers just after they had lost the World Series to the New York Yankees in 1952. Sitting alone on a trunk, tears streaming down his face, was the Dodgers' fine infielder, Jackie Robinson. His face spoke volumes on what it means to a dedicated ballplayer to lose. I had time to catch only a few pictures of him before a newspaper photographer strode up to him, shattering the mood, and asked Jackie if he would come across the room to pose with manager Chuck Dressen. Evidently the newspaper photographer wanted both men to stand gaping at each other and looking sad. He was oblivious of the great picture he had missed —and had come close to ruining for me.

And then there is the "mistake" that really isn't one at all. I was once with my family at a public swimming pool in Washington, D.C., taking shots of my daughters to send to grandparents on both sides of the Atlantic (my wife is Finnish). As I was taking those family snapshots, I noticed a boy, about 12 years old, jumping off the diving board in his own special way. He would run off the board, leap straight into the air, and squirt water from his mouth as he came down. I took him at the height of his act. The print looked so charmingly ridiculous I sent it to the editor at LIFE in charge of the Miscellany page, the spot for unusual photos that was used to end the magazine. The picture ran, with the headline, "A Squirt in the Sun." I've been told that it is one of the all-time favorites of Miscellany page photographs. The picture was a random shot; but it was no mistake. *Mark Kauffman* □

MARK KAUFFMAN: *A Squirt in the Sun*, 1953

The antics of a boy jumping off a diving board in a Washington, D.C., public swimming pool caught Kauffman's eye when he was there taking pictures of his daughters at play. Usually Kauffman considers working at photography during off hours an error to be avoided at all costs, but he snapped the boy and the result proved to be no "mistake." It appeared in LIFE in 1953 under the title "A Squirt in the Sun" and has remained to this day one of the photographer's most popular pictures.

Mechanical Failure 4

Techniques of Troubleshooting 102

How Sharp Is a Lens? 104

Simple Tests for Lenses 106

How Precise Is a Shutter? 108

Checking Synchronization of Strobe and Shutter 110

The Professionals' Tests 112

How the Prints Show What Went Wrong 114

Vignetting—The Lost Corners 116

Dirty Lens, Smudged Picture 117

Why a Shutter Misses Part of a Picture 118

Pictures Lost by Light 120

Disasters in Processing 122

Tracing Lines of Static 124

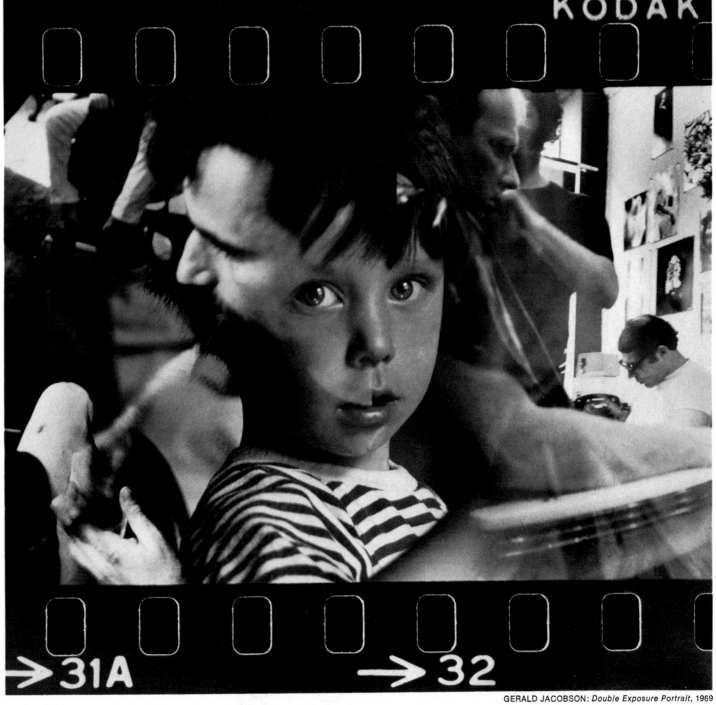

KODAK

➜31A ➜32

GERALD JACOBSON: *Double Exposure Portrait,* 1969

Techniques of Troubleshooting

In February 1968, as debate raged throughout the nation over American bombing raids in Southeast Asia, LIFE photographer Co Rentmeester arrived at a United States air base in Guam with a satchelful of sophisticated camera equipment. His plan was to fly aboard a B-52 bomber on a mission over North and South Vietnam, and to take pictures as the jet dropped its bomb load on Communist supply lines and ammo depots. To catch the bombs at the very moment that they spewed from the belly of the aircraft, he fitted remote controls to a motorized Nikon and installed it in a wing. Sixteen hours of painstaking work were needed to attach the camera and to lead its triggering cable through the wing to the cabin where he would sit. It hardly seemed worth it in the end. He flew three high-altitude missions, but each time, despite winterizing, his camera froze. Only by mounting a second motorized Nikon in the warmer bomb bay and by shooting when the bay doors opened and the bombs were released, did Rentmeester manage to come back with the kind of picture he was after.

Camera malfunction is probably the photographer's blackest nightmare. Whether the trouble lies with the expensive, specialized equipment of a professional like Rentmeester or with an amateur's standard gear, the effects in lost time and wasted pictures can be heartbreaking. Many things can go wrong. In the camera, the metal springs that close shutters can lose their tension. A sharp jolt can wreck a focusing system by knocking lens elements out of alignment. Parts can deteriorate from long use. The mechanism that simultaneously advances the film and cocks the shutter can wear out, resulting in multiple double exposures. The retractable mirror in a single-lens reflex, situated directly behind the lens to allow the photographer to focus, can fail to pull back when the shutter is tripped, so that the image never reaches the film and no exposure takes place. Continuous vibrations from an automobile or airplane can shake parts loose in a camera. LIFE science photographer Fritz Goro, shooting pictures of an archeological dig in Guatemala in 1963, produced several rolls of light-struck negatives. A tiny fitting in the base of his Rolleiflex had vibrated loose during the helicopter flight to the dig, so that sunlight streamed into his camera like the beam from a miniature flashlight. If Goro had not backed up his Rollei pictures by taking additional shots with another camera, his assignment would have been a total failure.

Many such disasters become apparent only after the pictures have been processed, and close study of prints is often the best way to detect malfunctions. But the professional tries to prevent trouble by periodically testing his equipment. Before setting out on an assignment he often aims his camera out a window and focuses on a distant building to make sure that the image is sharp when the focusing scale indicates infinity. By opening the back of the camera, looking through the lens and clicking the shutter, he can see

whether the shutter opens and closes smoothly. He makes sure that the batteries in their flash units and light meters operate effectively. After loading a 35mm camera, he can tell whether the film will run through smoothly by clicking off a few frames, and seeing if the rewind knob turns as he cocks the film-advance lever. For a more exhaustive check-out, working photographers send their cameras to a repair shop. Some publications maintain their own. *The National Geographic* magazine, for example, considers testing so important that it asks photographers to turn in their equipment for a thorough checkup after each assignment. And some manufacturers send teams of experts from the factory to major scheduled news events, such as moon shots and political conventions, to offer free testing and repair service to the professionals on assignment there.

Repairmen rely on a battery of complex optical and electronic equipment *(pages 112-113)* to ensure the accuracy of their tests. Oscilloscopes trace a graph on a screen to indicate exactly how long a shutter stays open at each setting. Battery testers determine the strength of flash batteries, and a lamp with an opal-glass screen and a dial for regulating light intensity allows technicians to make certain that light meters register correctly for all degrees of brightness. But such special equipment is not really necessary for most tests. Much information can be discovered at home by an amateur with no more equipment than a few charts, a tape measure, several rolls of film, phosphorescent tape and a magnifying glass.

Do-it-yourself tests like those that follow, applied either to the camera itself or to pictures made with the camera, can reveal most common defects. They are invaluable for detecting hidden faults in newly purchased cameras and lenses, particularly if the equipment is bought secondhand. And they also provide a convenient way of checking out a favorite old camera, indicating if it should go to the repair shop before a once-in-a-lifetime photographic opportunity is lost.

How Sharp Is a Lens?

The heart of a camera is its lens. Finely constructed shutters, precise focusing systems, lightproof, sturdy housings —all will be of little help to the photographer in search of fine pictures if his camera lacks a good lens, or if his lens has somehow got out of adjustment. Camera manufacturers are so particular about the quality of their lenses that they often take as much trouble testing them as they do making them. Before a new lens design goes into production, manufacturers sometimes spend weeks testing a prototype, probing it with light rays and laser beams, feeding hundreds of statistics into computers for evaluation. Later, as finished lenses leave production lines, they are tested again to make sure they conform to the same high standard as the prototype.

Even so, no lens is ever perfect. The most carefully constructed lenses will have certain built-in aberrations because of the peculiar ways in which light rays travel through curved pieces of glass. Images will be sharper at certain apertures than at others, and they will usually be sharper at the center than at the edges. Some lenses will produce clearer images with blue light rays than with yellow ones, and some are particularly likely to pick up unwanted flashes of reflected light, or flare. Though none of these faults can be eliminated entirely, lens-makers rely on testing to make sure they are kept to a practical minimum.

One basic test evaluates lens resolution—the ability of the lens to render detail; it can be carried out by the amateur, as described on pages 106-107. The test determines how many lines per millimeter the lens can distinguish at a prescribed distance from a target. There are a number of different versions. One pattern, for instance, was developed for the U.S. Air Force to test lenses used in aerial reconnaissance, where good detail is essential. But all versions of the resolution test are carried out in basically the same way, by photographing a wall chart covered with a number of carefully designed test patterns. Each test pattern (one example is shown opposite) consists of groups of lines of different sizes separated by varying widths of blank space. The developed negative is examined through a magnifying glass. The groups of larger lines will appear sharp, but some of the smaller groups will blur into each other. The smallest group that the lens is able to separate into clearly defined lines and blank spaces will be a measure of its resolving power.

Many variables besides the quality of the lens may affect the results of the resolution test. The film used and the process by which it is developed both influence the sharpness of the negatives. More significant, perhaps, is the fact that the test may uncover defects in the camera body or the focusing system. An uneven lens mount, a pressure plate at the back of the camera that does not hold the film firmly in the focal plane, or an inaccurate range finder all create a telltale blurring in the lines of the test patterns.

A test pattern, designed during the Korean War to check the resolving power of Air Force camera lenses, is shown enlarged 2½ times. It consists of 24 groups of lines of diminishing size, with each group containing three vertical lines and three horizontal ones. A number of such patterns arranged on a wall form the target for the resolution test. The numerals next to each line group refer to a table that lists the resolution in lines per millimeter.

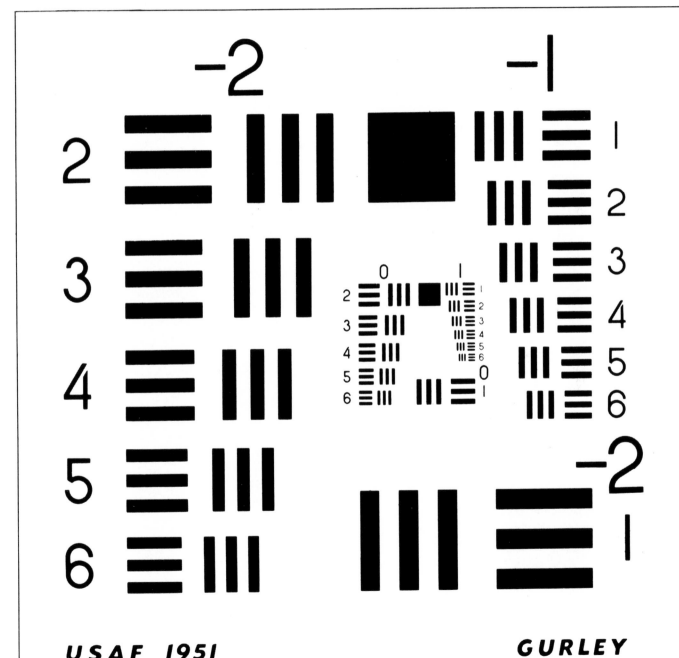

Simple Tests for Lenses

Using a resolution chart to test the sharpness of a lens requires the utmost accuracy and care. The camera must be properly placed, lighting must be precise, and the film must be developed in a specified manner. But an amateur, following the right procedures, not only can determine a lens's resolving power, but can check it for various types of distortion and aberration as well.

The first step is positioning the camera and chart. (Opposite, at left, is a negative of one standard chart, consisting of 16 test patterns arranged in a cross.) The camera must be placed securely on a tripod at a distance from the chart of 26 times the focal length of the lens. Thus, a two-inch (50mm) lens should be 52 inches away from the chart; a six-inch (150mm) lens should be 156 inches away.

The camera should be loaded with a high-resolution film, such as Panatomic-X, and a series of exposures made, one at each f-stop, while the shutter speed is adjusted so that the exposures remain constant. After exposure, the film should be carefully developed in a fine-grain developer.

The results of the test must be read directly from the negative through a magnifying glass. Using an enlarger to make a print would add another variable—the enlarger's lens—and could give misleading results for the camera lens. With the Photo-Lab-Index chart shown here, resolution in lines per millimeter is indicated by numbers next to each group of lines in the test patterns. To obtain the lens's resolving power, read the smallest group of lines in each test pattern that the lens is able to differentiate clearly.

Test results can tell more about a lens than just its overall sharpness. Almost all lenses have an unavoidable defect called spherical aberration. This means that they tend to form sharper images with the light rays that come through the center than with the rays that enter through the edges. Therefore, the negatives taken at the smaller apertures, where the edges are blocked off by the diaphragm, will probably show greater resolution than negatives taken at wide-open apertures. A careful examination of the negatives reveals which apertures will produce the least spherical aberration—and thus the sharpest pictures—in a given lens.

Other defects may show up on the negatives. The test patterns at the corners of the chart may be fuzzier than the ones near the center, indicating that the sharpest image the lens forms is curved slightly. Astigmatism—inability of a lens to reproduce horizontal and vertical lines equally well at the same time—shows up because the lines in each test pattern run at right angles to one another. Finally, a glance at the three long lines that frame the edges of the chart may show that the lens distorts images. If the lines bow inward the lens suffers from what is known as pincushion distortion; an outward bowing means barrel distortion *(opposite, top)*.

Standardized test charts, which give an accurate, numerical reading of a lens's resolving power, are available through most camera supply shops. But even without a chart an amateur can estimate the quality of his lens by substituting another flat surface with right-angle lines, such as a brick wall *(opposite)*. While the results are not as exact, they provide clues to many of the same defects that test charts show.

Accurate positioning of camera and lights is essential for getting good results from a test chart. The camera's lens must be centered exactly opposite the center of the chart, as shown above. If the camera is set at the slightest angle to left or right, or tilted up or down the smallest bit, the test will be misleading. Lights should be placed to provide even, glare-free illumination. In the arrangement shown here, two 15-watt frosted bulbs set in satin-finish reflectors are placed on either side of the camera at an angle of approximately 45°.

The test results for one lens, obtained from both a Photo-Lab-Index chart (left) and a brick wall, show barrel distortion. The parallel lines on the top and bottom edges of the chart, and the upper and lower rows of bricks, are bowed.

Another test from a different lens shows no sign of distortion. This particular lens also seems to have a greater resolving power than the lens tested at the top, since details in both the chart and the brick wall appear to be much sharper.

Disasters in Processing

Mishaps in the darkroom can ruin pictures just as effectively as broken-down camera equipment. For the whole process of developing and printing a picture demands the delicate, exacting care needed for preparing a soufflé. Chemicals must be fresh and properly mixed or negatives turn out under- or overdeveloped; temperatures must be correct to make the emulsion produce a properly developed image; timing must be precise to ensure the proper degree of development. Even a slip in loading film onto a reel for development or insufficient agitation can ruin a picture *(above and opposite)*.

Darkroom disasters always show up on finished prints. White spots are a common flaw. They may be caused by dust or lint on the negative, and darkrooms should be kept as free of dust as possible—even walls should be wiped down regularly with a damp cloth. Dark splotches may result from air bubbles, which adhere to the surfaces of negatives when they are in the developer, thus preventing the chemicals from reaching the emulsion. Since air bubbles form in developer when film is being introduced, a tank should be tapped gently to eliminate them. Other defects, such as streaks and blank spots, can usually be traced to their sources with a little detective work.

A segment of totally undeveloped negative resulted when two parts of the film stuck together during the initial stage of development. The photographer's carelessness in winding the film onto the wire reel of his developing tank caused one loop of film to rest against the loop next to it, thus preventing the chemicals from reaching the emulsion at the area of contact.

→ 17 → 17 A

Dark streaks near sprocket holes (above) are
caused by stale fixer and insufficient
agitation of the developing tank. Enough fixer
flowed through sprocket holes to halt
development near the holes; but development
continued on the rest of the negative.

Tracing Lines of Static

Professional photographers generally take pride in their talent for creating startling effects. But the bolt of lightning that appears to be striking the policeman on the sidelines *(right)* was a completely unpremeditated stroke—the chance effect of static electricity streaking across the film emulsion in the camera. The picture was taken at Yankee Stadium in New York during a game between the Giants and the Pittsburgh Steelers, on just the kind of crackling-cold, dry December day that causes sparks to jump between fingers and metal door handles—and, sometimes, from camera to film. The camera was a motorized Nikon that sped film through the camera at the rate of three frames a second, fast enough under cold, dry conditions to generate a sufficient charge for a spark.

Static electricity sometimes blights film in the darkroom. Pulling undeveloped film away from its paper backing too quickly can result in clusters of star-shaped static marks. Rubbing a hand along a strip of undeveloped film on a dry day may generate enough static to produce a row of black dots on the negative. It can sometimes be prevented from occurring in the camera simply by wiping the pressure plate with a solution of household detergent and water and permitting the plate to dry before loading the film. ☐

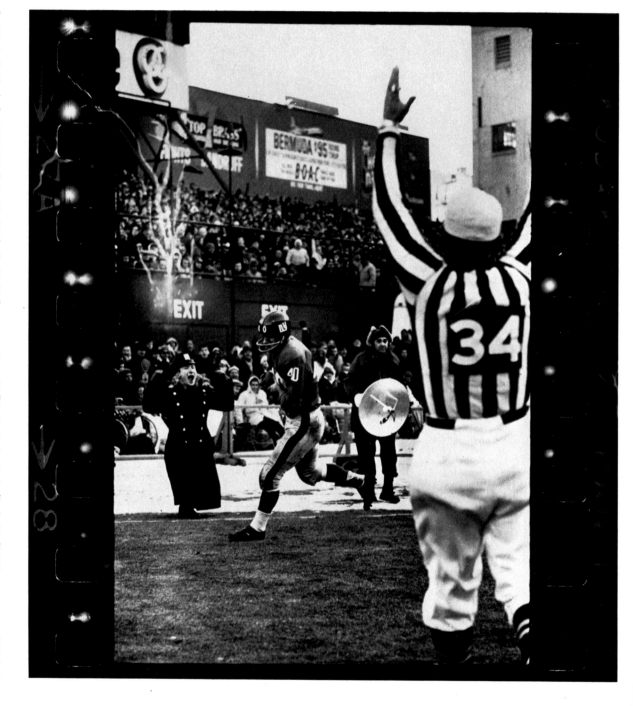

Catching the excitement of a Giants touchdown play, this shot registers dramatic currents that were not really there—a lightning flash caused by static electricity inside the camera.

Photographing Action 5

Making a Still Picture Show Movement 128

Sports Photography—A Game without Rules 134
The Critical Instant 136
A Sequence to Show a Steal 138
Emphasizing Speed with Distortion 140
Freezing Action without Special Equipment 142
A Race Frozen by a Flash 144
Showing Motion with Background Blur 146
Panning at Perilous Speed 149
Obtaining New Views of Elusive Action 150
Suiting the Angle to the Sport 152
Zeroing In on a Race with a Zoom Lens 154

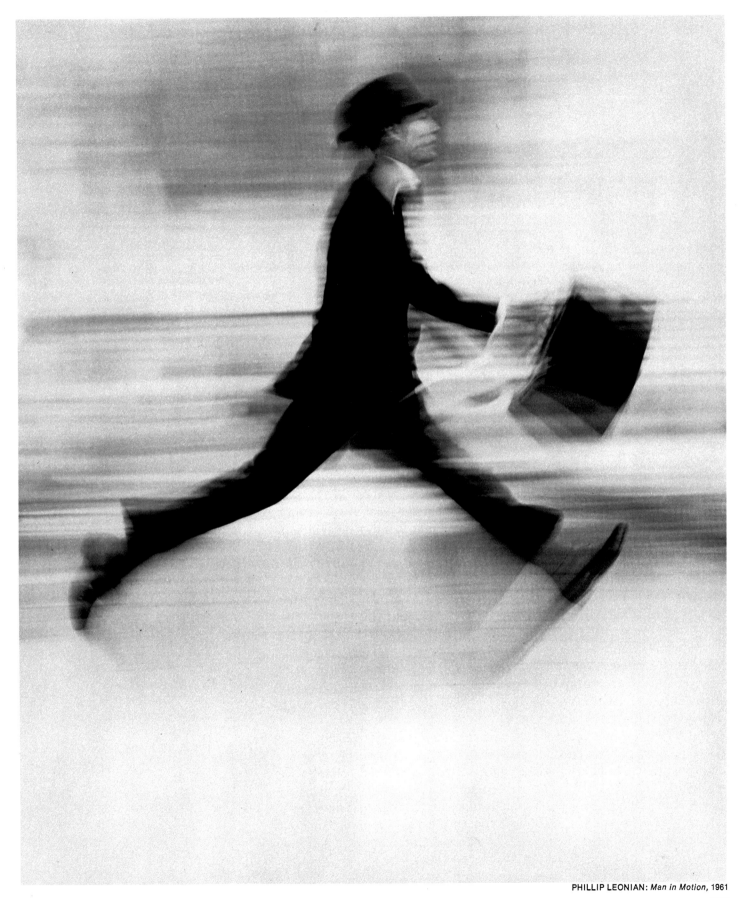

Making a Still Picture Show Movement

The businessman hurries along a busy New York City street, his stride wide, his briefcase swinging, his hat somehow remaining firmly on his head *(preceding page)*. His gait tells us that he is in a rush. But to add to the sense of action, the photographer has allowed portions of the body to blur. Through this simple effect, a routine study of a walking man suddenly becomes an ingenious demonstration of motion portrayed on film.

All around are similar opportunities for making ordinary subject matter into extraordinary pictures by the simple expedient of conveying action. Few things in the real world stand still. Trees sway, children run and wrestle on the lawn, friends talk and gesticulate, traffic rushes by. Some situations are packed with action. Not just sports, although these provide great pictures for photographers—amateur as well as professional—who know how to get the shots that re-create a game's excitement. Though all kinds of events that are part of everyday life are photographed endlessly, too often they are photographed poorly because the action that animates them is missed. The tumult of a child's birthday party, a trip to an amusement park, a dance in the recreation room, a family picnic, a cocktail party—all are picture-making opportunities that call for special skill in conveying action if the pictures are to be more than routine.

One reason so many photographers fail to make the most of their opportunities to convey action is a mistaken belief that any kind of motion is the enemy of good photography. This prejudice is a hangover from the old days of slow film's bulky cameras and inadequate shutters. It seemed then that every other shot was marred by the blurred outlines of a squirming child or the suddenly turned head that fuzzed a smiling face. "Hold still," was the universal command from behind the camera. Such restriction is no longer necessary, for modern equipment does not demand rigid posing. The photographer who recognizes that fact and begins to seek and emphasize motion in his subjects will find a new dimension added to his picture making —but he will also find he has taken on a host of new problems. While they are varied, they all relate to one basic question: how can movement be shown in a photograph that does not move?

The answer to that question is simple and seemingly discouraging: it cannot be. No way has ever been found to record motion exactly the way the eye and brain perceive it. Even the pictures of movies and television do not move; they only seem to because of an optical illusion. The physical impossibility of recording motion has intrigued artists for many thousands of years, and they have worked out methods for conveying the idea of motion, if not the actual motion itself, in images—drawn, sculpted or photographed—that do not move. There are only three basic techniques:

1 | Freezing the action, with every detail clear and sharp, suggests that the

eye has caught a quick glimpse of an object, isolating one instant from a continuous flow of movement.

2 | A sequence of separate pictures conveys the pattern of movement, showing not one part of it but several parts as the motion progresses from beginning to end.

3 | Blurring, which appeared rather late in the history of art, conveys an impression of speed because the eye, too, sees rapidly moving objects—such as a spinning airplane propeller—as a blur.

A most dramatic way of portraying action in photographs is by freezing motion. This technique produces the most familiar of the action shots—the runner breasting the tape at the finish line, the woodchopper in mid-swing, the party jokester with his head thrown back, laughing at his own story. The faces are easily recognizable, the pictures are unmarked by blurs, and such movements as arm-waving are caught in mid-motion but are nevertheless sharp. This fidelity to detail contains one drawback—it somehow lessens the realism of the picture. The human eye cannot pick up such detail from figures in motion. The camera sees better than the eye, its super-reality adding an air of unreality. But because stop-action photographs pick out detail the eye would miss, they can often be stunning in their visual impact, presenting an entirely new perspective on the world.

It is easy enough to make stop-action pictures when a high-speed strobe unit or a fast shutter speed can be used. A small strobe gives a flash of light lasting only about 1/1000 second, an exposure short enough to freeze the most energetic child jumping on his bed. And many 35mm cameras also provide shutter speeds of 1/1000 second, fast enough under certain circumstances to stop a 60 mile-an-hour car. But when such brief exposures are impractical, and they often are for one reason or another, action can still be frozen by a number of different techniques.

One of the most useful ways of stopping motion is to catch the action at its peak. Then it seems to be in motion but is actually stationary, and it can be frozen with even the simplest equipment. A child at the high point on a swing or seesaw is at the peak of his action; he has moved as far as he can go in one direction and comes to a momentary halt before beginning to move again in the opposite direction. Peak action is part of any rhythmic movement—a dancer at the top of his leap, a golfer at the beginning of his stroke, a boy at the highest point of his jump over a fence. Shooting at that instant not only seems to freeze the action but also produces exciting pictures because it captures a high point, the precise moment when energy is about to be released as the motion reverses its pattern. The face of a child perched on a swing just before the downward arc begins is alight with eager anticipation. The diver and the pole vaulter at the top of their upward thrusts re-

veal in their expressions and body control the utter intensity of their efforts.

To achieve good peak-action pictures, the photographer must train himself to anticipate the elusive moment when motion comes to its fleeting halt. The open shutter and the peak action must coincide exactly. A shutter button pushed slightly too early or too late produces unwanted blurring. With practice, the photographer learns to press the button slightly before the peak action. This allows for the split second it takes for the brain to send the message to the finger and the added fraction of a second for the camera's mechanism to open the shutter.

There is no peak to catch, however, in many kinds of action—a running boy, for instance, or a speeding car. Yet such continuous motion can also be frozen with slow exposures and simple equipment. One technique that works in these cases depends on the angle of the camera and the relative distance from the subject.

The greater the distance between the lens and subject, the less the shutter speed demanded to stop action. This is because the farther the moving subject is from the camera, the smaller its image on the film and the less the image can move as the subject moves. From 25 feet, for example, the picture of a running child would be blurred if shot at a shutter speed of 1/125 second. But this same picture taken at the same speed from 50 feet away will show an unblurred child. Thus, doubling the shooting distance greatly increases the capacity of the camera to freeze action.

As important as distance from the subject is the angle from which the picture is being taken. At 25 feet, a car speeding at 60 miles per hour straight across the camera's view can be stopped only with a shutter speed of 1/1000 second or faster. A slower shutter would produce only a long blur. Yet the speeding car, if photographed from head on, could be captured sharp and clear with a shutter speed of only 1/250 second. When the car streaks across the camera's field, the image shifts from one side of the scene to the other creating the extreme blur of motion. From head on, or an angle up to about 45°, the car's image does not really move very much. Its motion is principally its fairly slight increase in size as it approaches. (Head-on shots, even of a car, are perfectly feasible and safe if made from a vantage point on a turn.)

When distance or angle cannot reduce image movement enough to stop fast action, turning the camera—panning—will do so. If the subject is kept continuously centered in the viewfinder by careful panning, its image will always stay in the same spot on the film and there will be no blurring. Panning is a fairly simple technique that becomes almost automatic if it is practiced regularly. The feet should be planted firmly on the ground to avoid jerking the camera, and the entire upper half of the photographer's torso should move from one side to the other, not the camera alone. The entire motion

should have a flowing grace that keeps the subject exactly centered.

Panning produces pictures in which the subject appears sharp while the background is blurred; the subject is recognizable and the blur helps reinforce the illusion of motion. When used to freeze a running boy in the midst of his sprint, for example, the drama of stopped motion is retained while the blurred backdrop makes obvious the fact that the boy is actually running.

While a stop-action picture freezes a moment for the photographer, a series of such pictures can provide the history of an event. Sequence photographs, taken in rapid succession, can be made with almost any camera, even fairly simple ones, but they are easier to manage if the film-advance and shutter-cocking operations are combined in one device; or better yet, are entirely automatic. Several cartridge-load cameras, priced between $30 and $145, have spring-wind motor drives that advance the film automatically. Most 35mm cameras can be operated manually in rapid sequence, since only two steps are necessary: pressing the shutter release, then advancing the film and recocking the shutter with a single swing of a lever. Both the cartridge-load and 35mm cameras can take a picture every second.

Making a series of pictures works particularly well for photographs of children. A boy running across the lawn with the family dog, an act that may cover only a few seconds, becomes a study of youthful exuberance. Child portraits are easier to make this way, too, for the sitter can be allowed to move about as much as he wants while the camera clicks away. And few pictures of youngsters are more charming than a series that begins as a two-year-old tentatively digs a spoon into some cake and ends when his face is smeared with chocolate.

While stop-action and sequence pictures halt action for closer inspection, their very clarity may belie the sense of motion. To simulate a feeling of action, many photographers deliberately blur pictures by using relatively slow shutter speeds. The shot of the busy businessman *(page 127)* is an example of a deliberate blur. It was made with a Hasselblad at ½ second while the camera was panned. The panning kept some of the figure sharp while the slow shutter speed gave partial blurring. The picture of Jimmy Clark racing in his Lotus on page 148 is a similar example of deliberate blur. Only the lower portion of Clark's face is sharp. The rest is blurred. Yet the images of the car and driver are clearly distinguishable even though not graphically delineated, and a sense of hurtling speed is conveyed.

Deliberate blurring lends animation and excitement to any action picture. A bird coming in to land on a feeding tray can be stopped sharp with a shutter speed of 1/250 second—except for the wings, which will blur. When taking pictures of guests at a cocktail party or wedding reception, the

photographer might want to show the faces clearly but blur waving arms and hands to convey the liveliness of the affair. This combination of frozen and blurred action can be achieved by slowing shutter speed and anticipating the moment when the guests are at their most active. For the best pictures, rehearsals may be necessary: the face of the hostess passing canapés, for example, should be recognizable, yet the arms and canapé tray might be blurred to show motion, and several tries may be needed to keep her head still while the tray moves.

Nowhere can a photographer find a better stage for action pictures than the playing fields of organized sport. The action is fast, colorful and played out close at hand, within full view. Few amateurs take advantage of this opportunity, although SPORTS ILLUSTRATED photographer Neil Leifer believes they could rival the professionals. To begin with they have more freedom to experiment, he points out, simply because they are unencumbered by assignments. This freedom enables them to shoot at will without the pressure of satisfying a picture editor or client.

One amateur who has become a weekend sports photographer is Robert Smith, an art director for a New York advertising agency. A lifelong camera buff, Smith began taking pictures of sports events at the high school near his home when his daughter, Wendy, became a cheerleader. He soon became intrigued with the potential of this special brand of action photography and began attending every football game the school played. The first problem he had to work out was getting onto the field, where he could shoot without interference from spectators. The solution was easy. He had already taken a number of good pictures of the team from the front row of spectators; he made enlargements of these photographs and left them at the coach's office. When Smith stopped by the athletic department the next week to promise more prints of future games, he found waiting for him warm thanks and a season pass admitting him to the sidelines.

For an amateur, Smith's photographic equipment is elaborate. He has a Nikon F with a zoom lens that goes from 80 to 250mm, which he uses about 80 per cent of the time at the games. Its wide range of focal length enables him to get full-figure shots of the players no matter where they are on the field. His other camera is a Nikkormat outfitted with a 300mm lens that he uses for long pass plays and kick returns. On sunny days he keeps both cameras loaded with ASA 400 film and set at 1/500 second and f/16. He is in search of clear, unblurred pictures, primarily so that the boys on the team can easily recognize themselves, or at least spot their numbers. For this reason he never blurs deliberately.

Good sports-action pictures require a feel for the game. Smith has learned

enough about football—and has seen enough games—to sense where the action is going to be. He likes to roam along the edges of the field and behind the end zone, going where he expects the next flurry of activity to take place. When he senses a pass on a third down with eight yards to go, he stations himself about 20 or 30 yards from the line of scrimmage, hoping the pass will come his way. If it does, he usually kneels for his shot, for two reasons—to set the players against the uncluttered background of the sky, and to keep spectators behind him from screaming at him to sit down.

Like many photographers, Smith sometimes prefocuses his camera. With shutter speed and aperture preset at his preferred 1/500 and f/16, he focuses on a point where he thinks the action will be—the goal line, for example—and then shoots when the runner crosses the line. (Similarly, a photographer shooting a horse race might, before the start, focus on the starting gate, on the first turn, and on the finish line, marking each of the focus points with a grease pencil on his lens-focusing ring.) Smith does not hesitate to use all his film. Three or four good pictures from a roll of film is a respectable average in action photography. He sometimes photographs sequences and talks wistfully about a motor for his camera, an expensive battery-powered attachment that advances the film automatically for a very rapid series of shots. But Smith is a realistic man as well as an avid photographer. The cost of the motor (between $360 and $550) and the extra film it would use up would be prohibitive. "I have a son in college," he says. "If I brought home a motorized Nikon, my wife would kill me."

The differences between what professional photographers want from a sports event and a skilled amateur like Smith are not that great. Primarily, the professionals are always searching for the different shot, the unusual angle, the fresh approach. Walter Iooss Jr., a SPORTS ILLUSTRATED photographer, likes the challenge of sports photography "because it's all been done before." Therefore, the photographer's job is to restate what's been done before with insight and imagination. To do so, Iooss relies heavily on telephoto lenses, either a 400mm or an even longer 600mm, which he uses with a motorized Nikon. To hold these heavy lenses steady—essential because their long focal length exaggerates blur from camera movement—Iooss employs a unipod, a support that has only one leg. Iooss likes the mobility the unipod gives him, enabling him to swing his long lenses around the field so that he can train them quickly on the ever-shifting scenes of action. With his long lenses, Iooss can focus on one player, even on his facial expression, isolating him, or his small zone of action, from the playing field and the throngs of fans in the multi-tiered stadiums. So doing, Iooss—like many another professional and amateur today armed with knowledge, imagination and modern equipment—brings forth the many faces of action. ☐

Freezing Action without Special Equipment

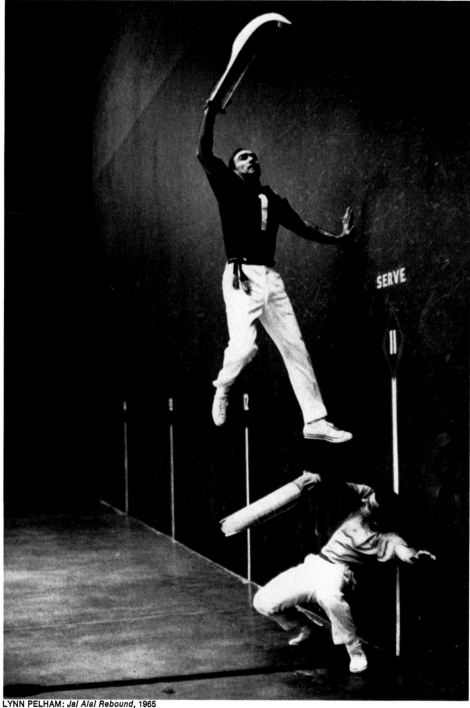

The peak moment, that fleeting instant when an action reaches a high point and movement momentarily halts, is recorded at a Miami jai alai game as a player bounds into the air to snatch the ball off the wall. Since the action had come to this brief pause, a shutter speed of 1/250 second was sufficiently fast to freeze it.

A spring straight at the camera, stopped in mid- ▶ air, powerfully conveys the dynamic energy of a collegiate broad jumper. Despite the speed of the action and only a relatively fast shutter setting—1/250 second—the image is unblurred. In a head-on view, there is little apparent motion of the subject, and it is easily frozen.

LYNN PELHAM: *Jai Alai Rebound*, 1965

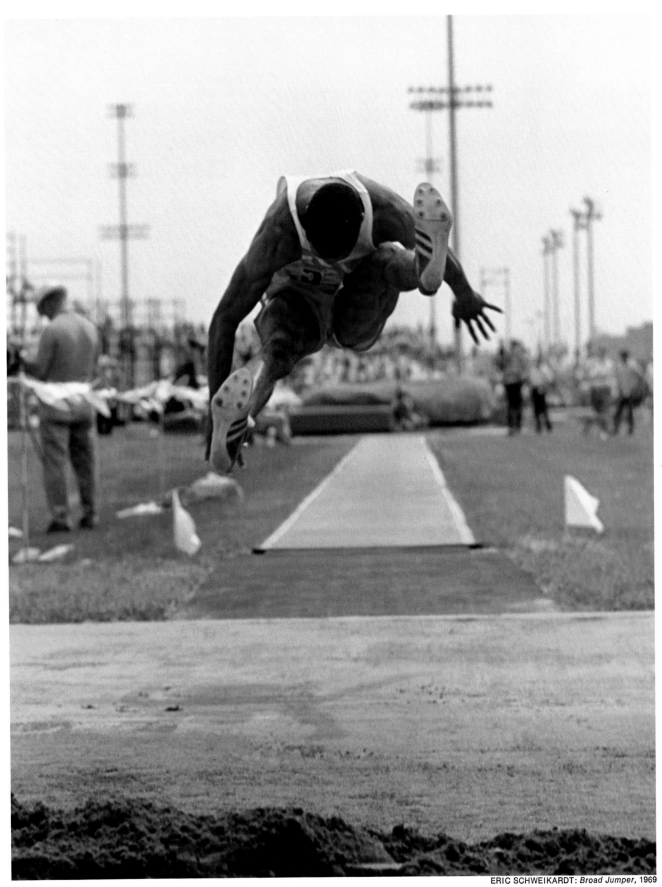

ERIC SCHWEIKARDT: *Broad Jumper*, 1969

A Race Frozen by a Flash

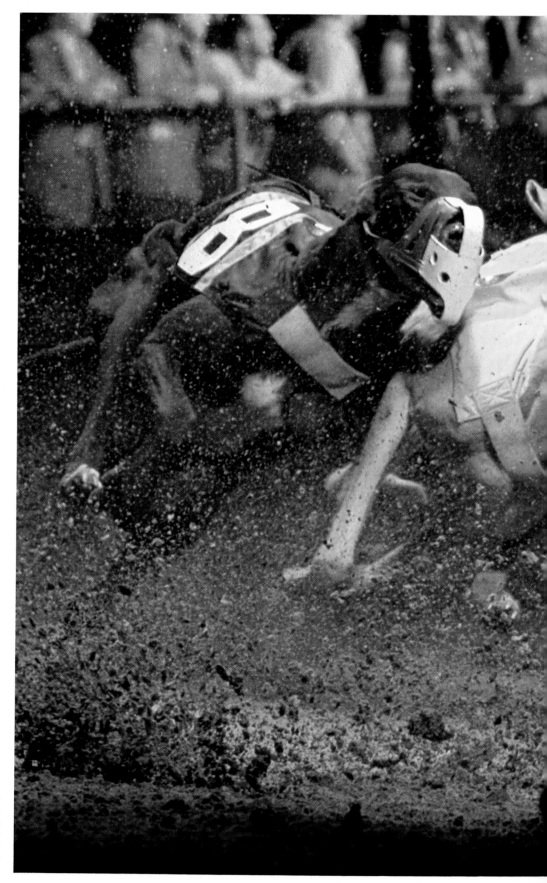

To dramatize the dirt-scattering frenzy of greyhounds racing in Arizona, John Zimmerman set up a bank of strobes over the track and shot the hurtling dogs from ground level. The strobes —flashed just after the front runner had passed under the bank—momentarily froze the dogs in frantic mid-air pursuit of the decoy rabbit.

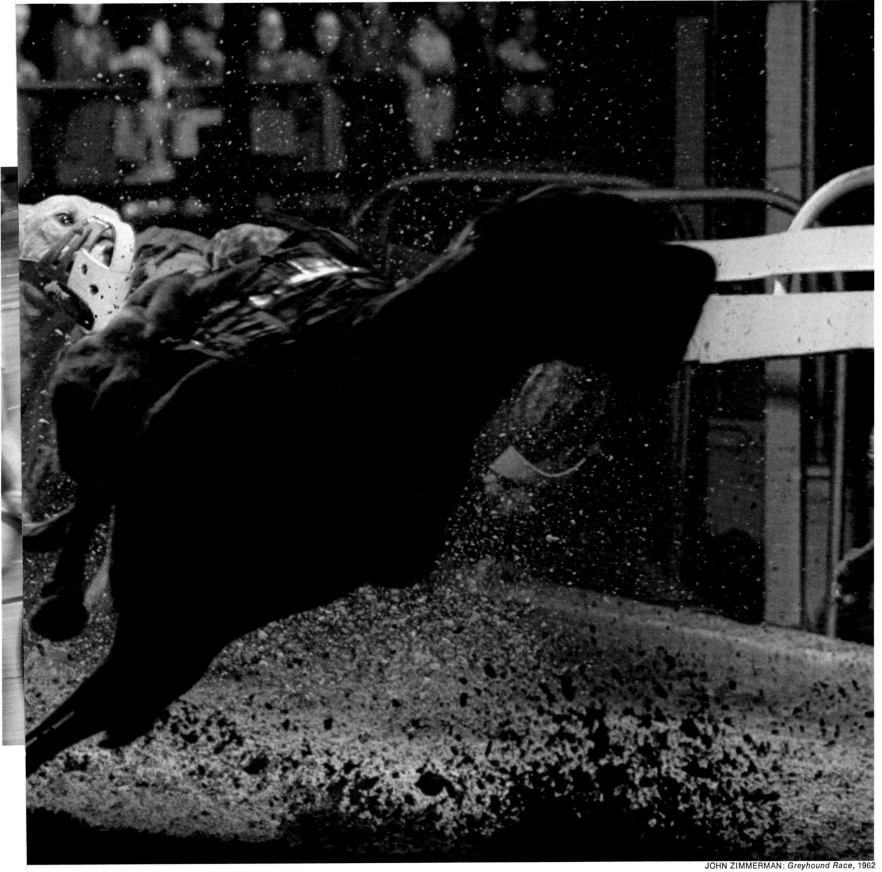

JOHN ZIMMERMAN: *Greyhound Race*, 1962

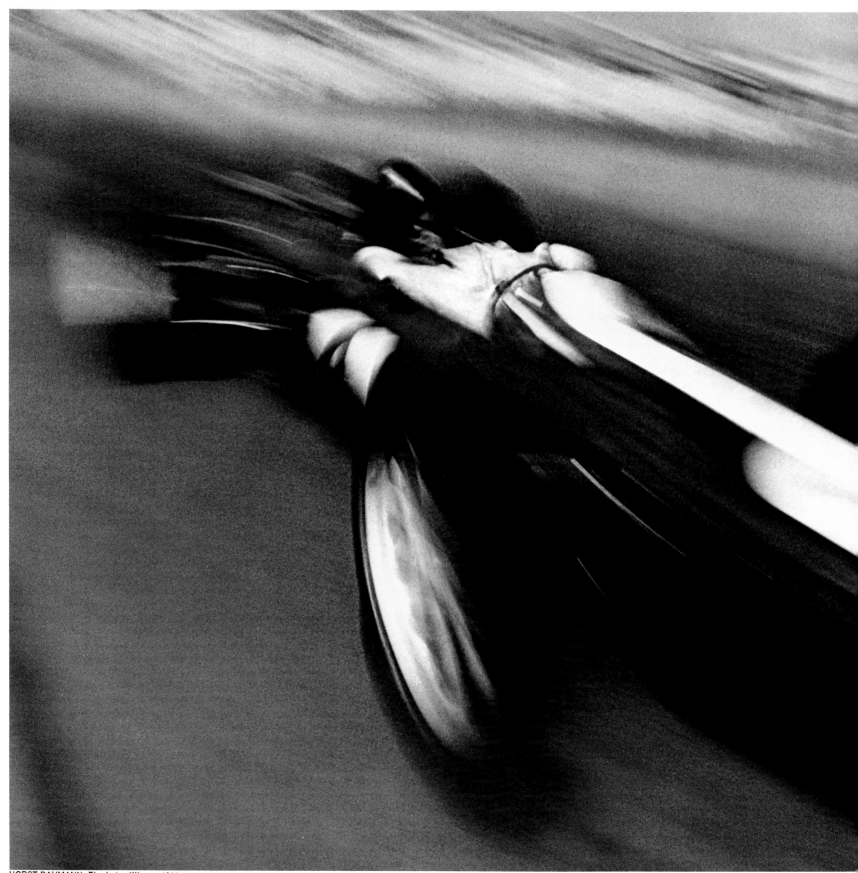

HORST BAUMANN: *The Lotus Winner*, 1963

148

Only three feet separated Horst Baumann from
Jim Clark's Lotus as it sped to victory in
Britain's Grand Prix. At 100 mph, the car
produced the blurred image Baumann sought,
suggesting the excitement and pace of the sport.
He panned with Clark's head, making it slightly
sharper than the car hurtling past the
blurred background of the track. To heighten
the impression of speed Baumann used a
wide-angle lens; its tendency to exaggerate
foreground objects elongated the hood so that
the entire car seems to lunge forward.

Obtaining New Views of Elusive Action

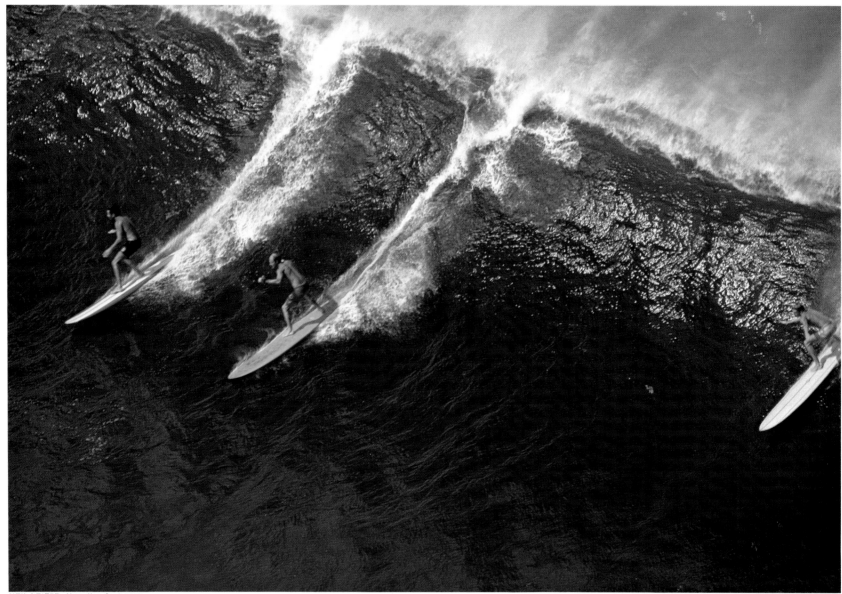

NEIL LEIFER: *Hawaiian Surf*, 1968

Patterns of foam and waves (above) were what Neil Leifer found when he took to a helicopter to photograph surfers on Waimea Bay, on the island of Oahu, in Hawaii. Shooting from above the action, he obtained not only a clear view of the surge and movement of a dangerous and hard-to-follow sport, but also an angle that lent itself to strong composition.

In photographing many a sport, the artistic challenge of conveying a sense of swift action may be outweighed by a more fundamental problem: getting close enough to show anything at all. The difficulty of getting within range is particularly acute in sports like surfing and sailing, where the moments of high drama—the riding of what might be the perfect wave, the turn of speed as a racing vessel's spinnaker fills—occur far from a photographer's usual van-

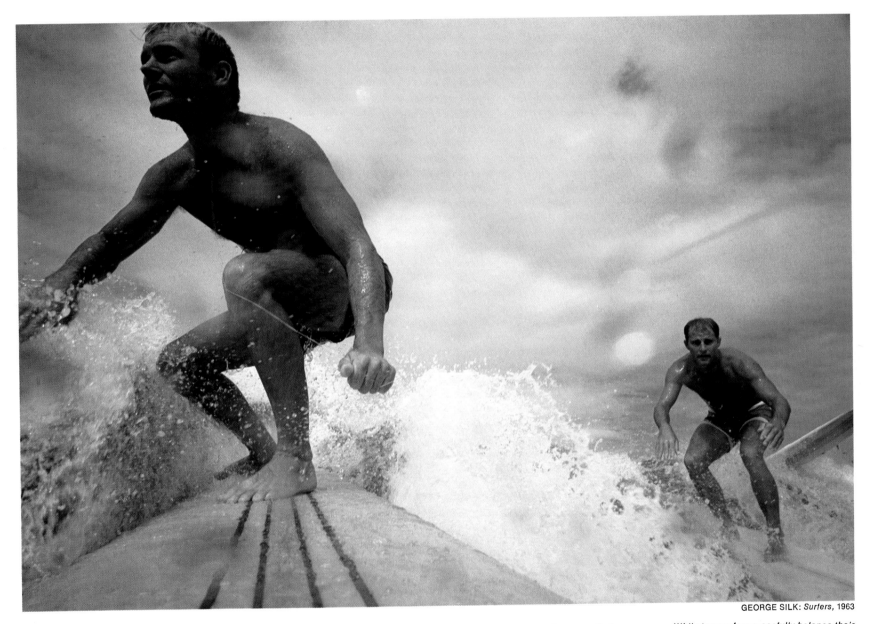

GEORGE SILK: *Surfers*, 1963

tage point, almost uncapturable from beach or dockside even by a man armed with such standard equipment as long lenses. But stunning pictures of such events can be obtained with special equipment that takes the camera to the athletes *(above and opposite)*. And if the photographer knows where to place himself, even standard gear can bring fresh visual excitement to such frequently photographed sports as baseball and horse racing. ☐

While two surfers gracefully balance their boards off an Oahu beach, a third *(far right)* has already wiped out in this dramatic wide-angle view that photographer George Silk obtained while standing secure and dry on the shore. He bolted a plastic-housed motorized Nikon to the board at left and ran a string from the controls to the left hand of the surfer.

Suiting the Angle to the Sport

JAMES DRAKE: *Denny McLain at Work,* 1968

Denny McLain's ball is stopped in mid-air in this Detroit Tigers-Cleveland Indians game. James Drake used a long 600mm lens to project himself—and the viewer—from his position far behind the batter and plate umpire (at right) directly into the action. The blurred figures frame McLain and direct the eye to the ball.

After sunrise, George Silk took up a 3 a.m. dare and had himself hoisted in a boatswain's chair to the top of the aluminum mast of the 12-meter *Nefertiti* to capture this bird's-eye view. He used a wide-angle lens on his Nikon SP, pointing it downward at arm's length to bring the ballooning spinnaker into the picture.

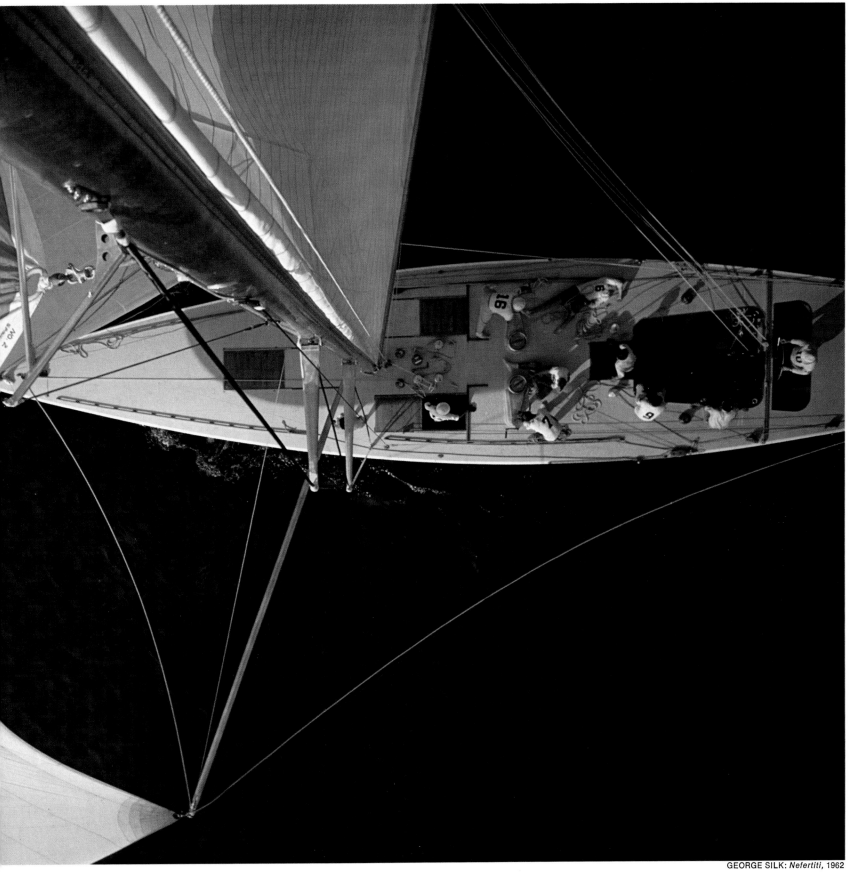

GEORGE SILK: *Nefertiti*, 1962

Zeroing In on a Race with a Zoom Lens

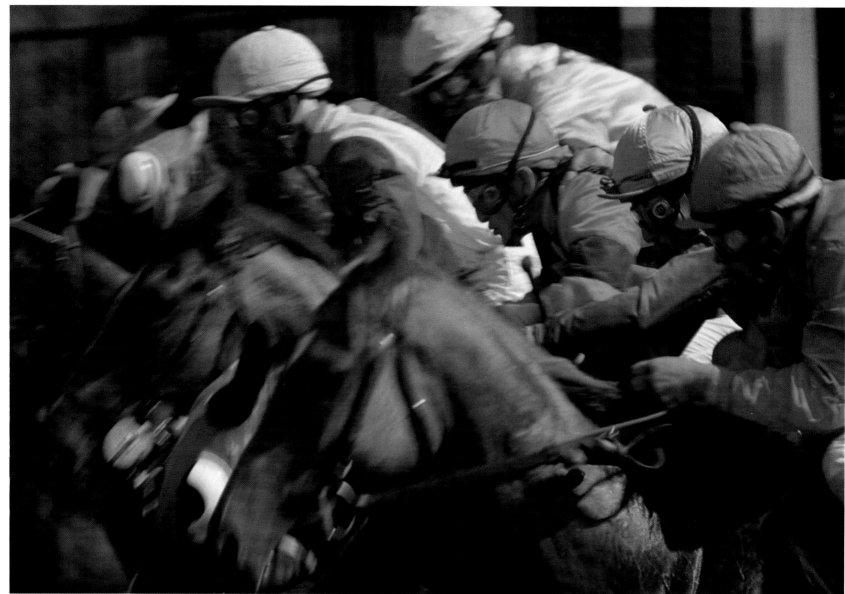

WALTER D. OSBORNE: *Starting Gate at Aqueduct,* 1964

*Walter Osborne's camera position—adjacent to
the starting gate—made it easy to cover horse-
race action with a normal lens. However, by
using an 85-250mm zoom lens set near 250mm,
he was able to compress the strung-out field of
thoroughbreds, blur the action slightly and
vividly convey the excitement and silken colors
of a breakaway start at New York's Aqueduct.*

Photography in the Classroom 158

A Wealth of Facilities for Learning 160

Problems That Teach 162

New Light on the Common Egg 164
Private Views of a New Environment 166
Reflections through the Camera's Eye 168
Exploring the Effects of Movement 170
From Three Dimensions, A Flat Design 172

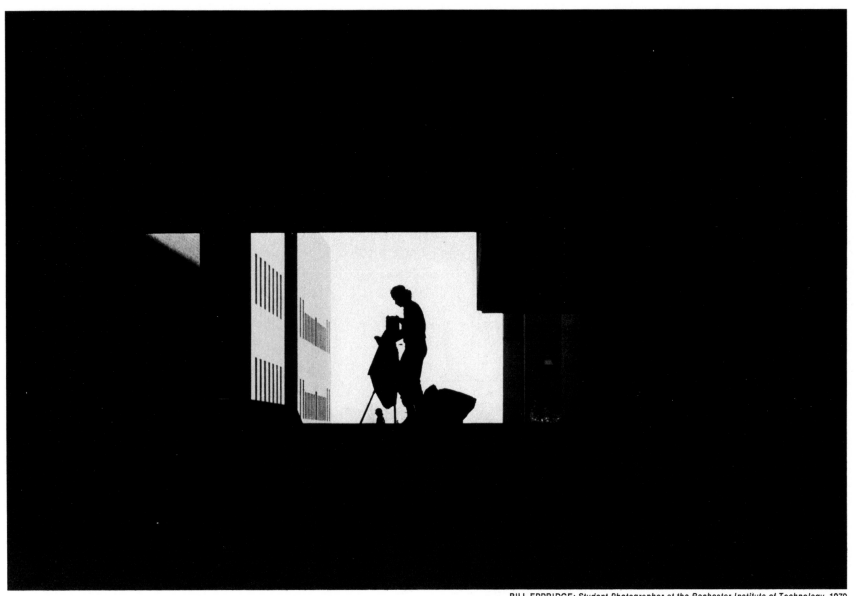

BILL EPPRIDGE: *Student Photographer at the Rochester Institute of Technology*, 1970

Photography in the Classroom

Today more and more people are finding out how to solve the problems of photography not by the haphazard process of trial and error but by going to school. In the past most young photographers perforce learned by doing, for only a sprinkling of American colleges and technical institutions considered photography an appropriate subject for study. "There was no place I could go . . . for photographic education," wrote Ansel Adams of his efforts in the 1920s to master the art of landscape photography. "Excepting the few kind individuals who provided assistance, and some nuts-and-bolts training in photofinishing shops, I trained myself—very inefficient!" To help aspiring young photographers avoid the frustrations he himself experienced, Adams has conducted a photographic workshop in Yosemite, California. In doing so, he contributes to a growing national phenomenon.

According to a survey conducted in 1968 by a member of the Department of Printing and Photography at Southern Illinois University, the number of United States colleges and universities that offer some instruction in photography had increased by two thirds in the previous four years, and the number of students had almost doubled, increasing from 14,000 to 26,000. By 1970, photography could be studied as a college course in 440 schools, and 48 of them offered bachelor's degrees for a major in photography. The range of subject matter taught in formal classes is very broad. Courses range from elementary introductions to picture taking and processing, through advanced seminars in photographic history, and on to such specialties as photography for television, medicine and law.

Photography is the major concern of a number of specialized private institutes and nondegree schools, where intensive training in photographic art and techniques is offered without the liberal arts courses that accompany most college programs. The institutions offering bachelor's degrees generally place photographic classes either in the journalism or art departments. Only seven have independent photography departments. Foremost of these is the School of Photographic Arts and Sciences, part of the Rochester Institute of Technology, which is located in upstate New York. The Institute, founded in 1829 when Rochester was a frontier farming community, is an enormous complex of science, business and arts colleges housed on a 1,300-acre campus of modern, brick buildings on the outskirts of Rochester. The Photography School is one of the Institute's major entities and offers a greater variety of photography courses—38 in all—than any other institution in the country, and confers both a Bachelor of Fine Arts and a Bachelor of Science degree.

Like other students at the Institute, those in the School of Photography tend to concentrate on the practical—understandably. Rochester is an industrial town, and one of the best places in the world to earn a living in

The campus of Rochester Institute of Technology, completed in 1968, includes seven different colleges, as well as libraries, athletic facilities and a student housing complex. This view from the top of the College of Graphic Arts and Photography shows the College of General Studies (left) and the James E. Booth Memorial Building of Fine and Applied Arts.

photography. Photography is in the air. It was here that George Eastman in 1888 began manufacturing the simple box camera that expanded picture taking from the hobby of a dedicated few into a national craze. It is here that the Eastman Kodak Company, now the world's largest manufacturer of cameras and film, still maintains its headquarters. Kodak lends close support to the photography school. It provides guest lecturers, occasionally offers advice on the curriculum, opens its libraries and gives technical advice to students working on special projects—and hires many of them when they complete their education.

Partly because of this industrial backing, R.I.T. has the most elaborate facilities in the country. It is the only school to educate students for degrees in a technological specialty called Photographic Science and Instrumentation, turning out engineers who design new cameras, concoct new kinds of film and develop the complex photographic equipment used in many branches of scientific research. The even more specialized Department of Bio-Medical Photography offers the country's only collegiate program in the techniques of photographing living organisms for scientific research.

Most of R.I.T.'s 860 photography students are concentrating on becoming well-rounded professional photographers. "We are preparing young people for meaningful jobs," explains the school's director, William S. Shoemaker. In addition to basic classes in picture taking and laboratory techniques, the students can choose from elective courses in portraiture, advertising photography, photojournalism and motion-picture photography. One major program in professional photography, leading to a Bachelor of Science, includes training in business management and accounting for students who plan to enter industry or to open their own studios. Another program concentrates on esthetics, and leads to the fine arts degree. In both, the emphasis is on learning by doing. From virtually the first day of class, students are assigned challenging photographic problems, and sent out of class to solve them. The result of this guided do-it-yourself approach, Shoemaker hopes, will be a highly developed sixth sense of "visual literacy"—the ability to think and communicate in photographic images. He sums up the goals of the Rochester school by saying, "We're trying to provide educational experiences that will teach young people to solve the problems of visual communication."

From Three Dimensions, a Flat Design

The distinguishing talent of Edward Weston, one of the masters of photography, was his ability to picture ordinary objects in such a way that their qualities of form and shape were emphasized, but the object itself remained recognizable. One of Weston's most famous pictures is a close-up of a ceramic toilet bowl he photographed from below to give it an odd sense of monumentality. The same utilitarian item, treated in a somewhat different way, was picked by R.I.T. freshman Judie Gleason for her own study in transforming normal appearances.

Miss Gleason's assignment was to photograph any three-dimensional object in such a way "as to reduce the illusion of three-dimensionality as much as possible," thus creating a flat pattern of light and dark shapes. At the same time, the object itself would have to retain its identity.

There is no mistaking the object Miss Gleason chose. Yet by a wise selection of visual design elements—a squarely overhead camera angle, careful framing and strong contrast of black and white—she has in effect created an optical illusion in which the solid toilet bowl seems almost as flat as the tile floor it rests on. ☐

JUDIE GLEASON: *Toilet Bowl*, 1967

The main visual clue that lets the eye recognize three dimensions is gradation in shading between light and dark. By including a minimum of gray tones in this view of a toilet bowl, Miss Gleason has produced a strongly two-dimensional pattern of black and white.

The Deliberate Mistake 7

How to Succeed by Breaking the Rules 176

Using Graininess to Make the Particular General 178

Stark Black and White for Emotional Power 180

Shadows to Startle the Eye 182

Drama from the Misused Film 184

Making a Point by Chopping Off Heads 186

The Power of Distorted Perspective 188

Tampering with Lenses to Break Up the Light 190

For Mystery, Focus on the Wrong Thing 192

Mellow Tints from Reciprocity Failure 194

Sun Shots to Turn Day into Night 196

Sacrificing Detail to Create a Mood 198

An Inferior Lens for Superior Effects 200

Indoor Film to Create a New View of the Outdoor World 202

Hardly anybody ever takes a picture of a boy fishing by shooting his bare feet. But the choice of a bizarre angle to do what nobody does, consciously refusing to accept ordinary rules, gave this picture its impact. It was taken at high noon on a bright summer day on Lake Washington near Seattle, with the camera aimed upward from under the fishing pier. Exposure calculated for the sky underexposed and darkened the silhouetted foreground objects.

HARALD SUND: *Barefoot Boy Fishing*, 1967

DAVID MOORE: *Torchlight Procession ot Skiers, Australla,* 1966

194

Mellow Tints from Reciprocity Failure

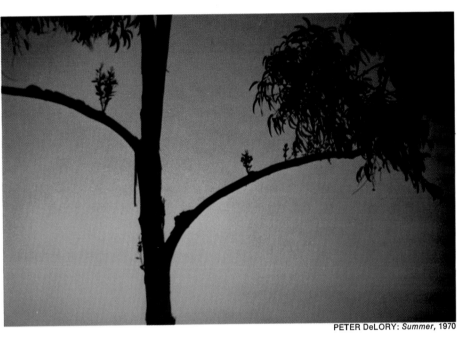

PETER DeLORY: *Summer,* 1970

The warm purple tint over the snow (left) and the two-toned sky in the picture above were produced by reciprocity failure. Both pictures were shot in the dim light of dusk and given lengthy exposures; David Moore exposed for the full five minutes it took the skiers to run the trail (the zigzag thread of light that bisects his picture). To avoid overexposure, he set his aperture at its smallest opening, f/22, thus reducing the amount of light admitted.

The "law of reciprocity" states that a long exposure in very dim light should give exactly the same result as a short exposure in very bright light. (In technical terms, the effects of light intensity and exposure time are reciprocal; an increase in one factor precisely counterbalances a decrease in the other.) That's the law. Film emulsions obey it —most of the time. But the law breaks down if film is exposed for more than five seconds in an extremely dim light, or for less than 1/1000 of a second in a very strong light; then the phenomenon known as "reciprocity failure" occurs.

Its cause is not entirely understood; most experts think it results when light is insufficiently intense to trigger the silver bromide crystals in film into forming a latent image. Reciprocity failure slows the speed of the film, which gives an underexposed, darkened black-and-white image. Something more happens with color films. Because they contain three separate emulsion layers, each of which may be affected differently, the varied speed losses change color balance. The result is color shifts, like those that give a pleasing cast to the two pictures shown on these pages.

Sacrificing Detail to Create a Mood

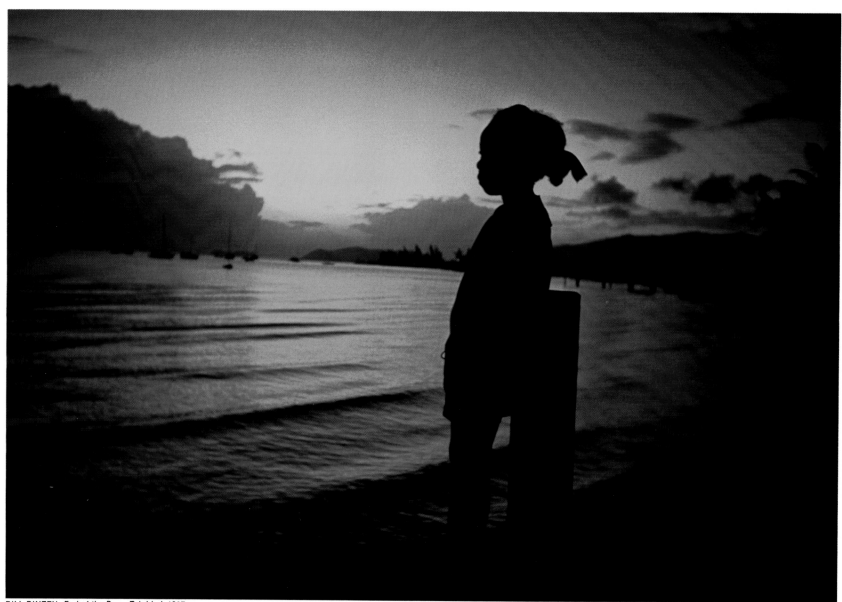

BILL BINZEN: *End of the Day—Trinidad,* 1967

*Even with exposure of two seconds at f/2.8, the
backlighted little girl in the foreground of
this dusk scene was underexposed. Bill Binzen
also omitted the pale blue or pale green filter
sometimes used to help tone down the
excessive redness of twilight. The brilliant
orange of his background is the actual color he
remembers seeing in the sky and water.*

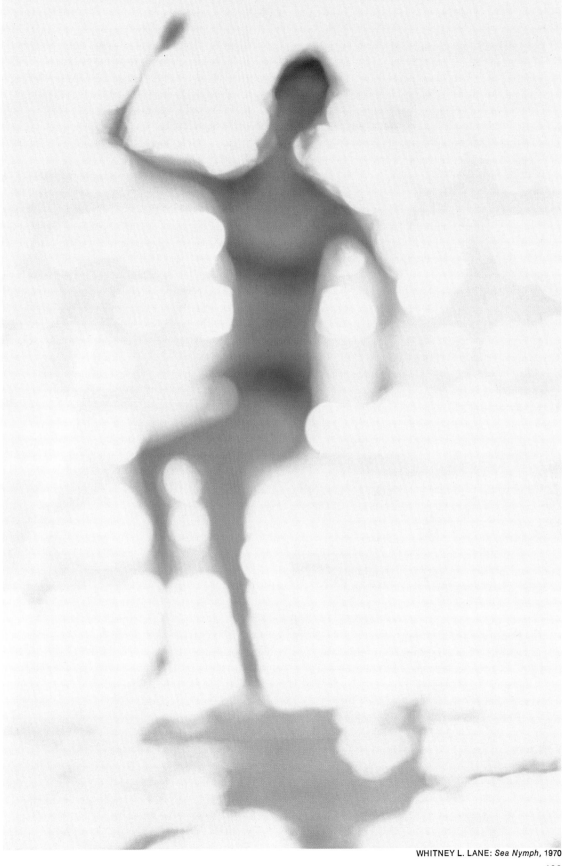

Both the pictures shown here were made with backlighting so strong that the figures become silhouettes almost entirely devoid of any detail. But each achieves its particular effect through a different technique.

Backlighting alone can eliminate detail, as at left, if the usual exposure recommendations are ignored. Exposing for the brightest parts of a scene instead of the dimmest reduces the most prominent elements to silhouettes and greatly simplifies the ideas they express—in this case the girl's posture and her placement in the scene convey a single impression, that of a quiet thoughtfulness.

Quite another feeling is suggested if the picture is not only silhouetted by backlighting but also thrown out of focus and overexposed (right). Detail is again eliminated, but now outlines are also distorted, partly because overexposure tends to spread the effect of bright light. This spilling over of light may wash out narrow dark areas such as the arms of this dancer, which are so thinned that the figure becomes an exuberant, unearthly wraith.

To catch the gaiety of a young woman frolicking on a Cape Cod beach on a summer day, Whitney L. Lane "played around with the focus until I got a blurry, elongated silhouette," then shot at 1/125 and f/4. This overexposure further blurred the image and made the girl seem as ephemeral as a water sprite come to life.

WHITNEY L. LANE: *Sea Nymph,* 1970

An Inferior Lens for Superior Effects

One reason for the high price of a good camera lens is the need for several separate elements, each shaped to work with the others in creating a sharp image. But a sharp image, every line and color in its proper place, would have dissipated the charm of the picture at right, which was made with a simple lens similar to a magnifying glass and prone to the defects so expensively removed from a fine camera lens.

A simple lens made of a single piece of convex glass causes blur in a number of ways. For one thing, it cannot get the edges of the image into sharp focus (unless the aperture used is extremely small); to correct that error, at least one other, differently shaped lens element must be added. For another, the single lens makes overlapping images of each of the colors in the spectrum. It bends each color to a different degree, thus splitting a ray of light into its component colors and bringing each of these separate components to a focus at a different point on the film. Correcting this "chromatic aberration" requires another lens element to cancel the color effects of the first; it must be made of a different kind of glass and shaped to bend light in a compensating direction. Because it lacks such corrections, the simple lens seldom produces a faithful reproduction of a subject—but it can transcend direct reproduction to create scenes of unusual beauty.

"This was a different approach to shooting fall —an attempt to capture pattern, line and design in an abstract view of fall foliage," says Henry A. Shull of his close-up of a sprig of maple, which he found beginning to turn color on an overcast October day in Vermont. He photographed it from a distance of two or three feet, using a Nikon set at f/2 and 1/500—but with the standard lens replaced by a piece of convex optical glass. This simple lens blends colors together to create surprising shades in the developed print.

HENRY A. SHULL: *Autumn Leaves*, 1970

Indoor Film to Create a New View of the Outdoor World

STEPHEN GREEN-ARMYTAGE: *Two Boys Fishing*, 1970

If a photographer wants a blue tone in his outdoor scenes he can use indoor color film, which is very sensitive to blue light. When the film is used indoors this weighting counterbalances artificial light's lack of blue and over-abundance of red, making the result look natural. Outdoors, where light colors often tend toward the blue, it can give a pleasantly monochromatic effect. (Conversely, outdoor film used indoors gives yellowish-red results.) ☐

When indoor film is used to take a picture in daylight, the result is the blue cast that gives this picture its distinctive quality. Photographer Stephen Green-Armytage could have "corrected" his color to achieve naturalistic lighting by using a yellow filter, but he preferred the monochromatic tints because he felt they would simplify the content of his picture.

Bibliography

Adams, Ansel, *Natural-Light Photography.* Morgan & Morgan, 1952.

*Birnbaum, Hugh, and Don Sutherland, *Photo Guide for Travelers.* Rivoli Press, 1970.

Croy, O. R., *Creative Photography.* Focal Press, 1965.

*Department of the Navy "Photographic Bulletin —Tips for Cold Weather Photography." COMNAVSUPPFOR.

Evans, Ralph M., *Eye, Film and Camera in Color Photography.* Wiley, 1969.

Eastman Kodak:

Adventures in Existing-Light Photography, Photo Information Book AC-44. Eastman Kodak, 1969.

Color Photography Outdoors, Color Data Book E-75. Eastman Kodak, 1969.

Kodak Black-and-White Films in Rolls, Photo Information Book AF-13. Eastman Kodak, 1967.

Kodak Color Films, Color Data Book E-77. Eastman Kodak, 1968.

Notes on Tropical Photography, Service Pamphlet C-24. Eastman Kodak, 1958.

Photography under Arctic Conditions, Pamphlet C-9. Eastman Kodak, 1967.

Prevention and Removal of Fungus on Processed Films, Service Pamphlet AE-22. Eastman Kodak, 1966.

Focal Press Ltd., *Focal Encyclopedia of Photography.* McGraw-Hill, 1969.

Fritsche, Kurt, *Faults in Photography: Causes and Correctives.* Focal Press, 1968.

*Hertzberg, Robert E., *Photo Darkroom Guide.* Amphoto, 1967.

*Jonas, Paul, *Manual of Darkroom Procedures and Techniques.* Amphoto, 1967.

Mees, C. E. Kenneth, *From Dry Plates to Ektachrome Film.* Ziff-Davis, 1961.

Mueller, Conrad G., and Mae Rudolph and the Editors of TIME-LIFE Books, *Light and Vision.* TIME-LIFE Books, 1969.

Pittaro, Ernest M., *Photo-Lab-Index.* Morgan & Morgan, 1970.

Smith, Edwin, *All the Photo Tricks.* Focal Press, 1959.

Spencer, D. A., *Color Photography in Practice.* Focal Press, 1966.

Periodicals

Aperture, Aperture Inc., New York City

British Journal of Photography, Henry Greenwood and Co., London

Camera, C. J. Bucher Ltd., Lucerne, Switzerland

Camera 35, U.S. Camera Publishing Co., New York City

Creative Camera, International Federation of Amateur Photographers, London

Infinity, American Society of Magazine Photographers, New York City

Modern Photography, The Billboard Publishing Co., New York City

Popular Photography, Ziff-Davis Publishing Co., New York City

Travel & Camera, U.S. Camera Publishing Corp., New York City

U.S. Camera World Annual, U.S. Camera Publishing Corp., New York City

*Available only in paperback.

Acknowledgments

For the help given in the preparation of this book, the editors would like to express their gratitude to Walter Clark, Rochester, New York; George A. Doumani, Science Policy Research Divison, Library of Congress, Washington, D.C.; Werner A. Fallet, Assistant Sales Manager, Zeiss-Ikon-Voigtlander of America, Inc., New York City; Martin Forscher, Professional Camera Repair Service Inc., New York City; Alfred Geller, Royaltone Inc., New York City; William Harmon, Nikon Inc., Garden City, N.Y.; Rudolf Kingslake, Retired Director of Optical Design, Eastman Kodak Co., Rochester, N.Y.; Phillip Leonian, New York City; Robert E. Mayer, Manager, Photographic Services, Bell & Howell Photo Sales Co., Chicago, Illinois; from the Rochester Institute of Technology, Rochester, N.Y.: Lothar K. Engelmann, Dean of College of Graphic Arts and Photography, William S. Shoemaker, Director of School of Photographic Arts and Sciences, John F. Carson, Staff Chairman, Photographic Science and Instrumentation, Edwin M. Wilson, Staff Chairman, Professional Photography, Tom Muir Wilson, Staff Chairman, Photographic Illustration, and the faculty and staff of the School of Photographic Arts and Sciences; Cleveland C. Soper, Research Associate, Eastman Kodak Co., Rochester, N.Y.; Mike Sutkowski, Office of Public Relations, Singer Diversified Worldwide, New York City.

Picture Credits
Credits from left to right are separated by semicolons, from top to bottom by dashes.

Index
Numerals in italics indicate a photograph, painting or drawing of the subject mentioned.

Aberrations: and resolution of lens, 106; for special effects, *200-201*
Adams, Ansel, 158
Agitation in processing, effect of insufficient, *123*
Air bubbles on film in developer, symptoms of, 122
Angle of camera: and elimination of distracting backgrounds, 50, *51;* and elimination of flare, *56-57;* and elimination of reflections, *53;* and stop-action photography, 130, 143, 152
Armstrong-Jones, Antony, 95
Auto-collimator, 112, *113*

Backgrounds: elimination of distracting, 46-47, *50-51;* error of unnoticed, *92-93;* retention of, in portrait, 60-61
Backlighting, *198-199*
Baker, Irving, *161*
Barrel distortion, 62; revealed by test chart, 106, *107*
Barstow, Jim, photograph by, *166*
Barton, Hugh, 162; photograph by, *163*
Bavagnoli, Carlo: photographs by, *86, 87;* and reversal of lens for photomacrography, 86
Bicycle-pump shutter release, 70, 72
Binzen, Bill, 198; photograph by, *198*
Blank frames, significance of, 114
Blank white areas on print, *120-121;* significance of, 114, 120-121
Blur: and aberrations, 106, *200-201;* and depth of field, *48-49, 50, 51, 54-55, 192;* and greased filter, 190, *191;* and photography of motion, *127, 129,* 131-132, *146, 147, 148-149, 170-171*
Burri, René, 183; photograph by, *182*

Camera(s): bodies, extra, 25; housing, nitrogen-filled, *76;* housing, waterproof, *18,* 20-21, 151; malfunctions of, 102-103, *114-124;* motorized, 76-81, 131, 133, 136, 151; repairs of, in the field, 24-25; slit, 134, 140, 146; tests for, *104-113*
Camera and equipment care: in cold environments, *19,* 22-24, 36, 40; in dry environments, 21-22; in dusty environments, *18,* 21-22, 26, 32; in hot environments, 13-14, *19,* 96; in humid environments, 15, 17, *19;* in wet environments, *18,* 20-21, 31, 35
Chemicals, effect of stale, 122, *123*
Circo-Mirrotach, *45, 68*
Cold environments: effects of, on exposure meters, 23; effects of, on film, 22-24; effects of, on lenses, 22; effects of, on shutters, 22, 36; effects of snow-covered terrain on exposure, 23; freezing of skin to equipment, 22, 23, 40; photographs taken in, *cover, 36-37, 38-39, 40-41, 42;* protection of equipment in, *19,* 22-24, 38, 40
Collodion emulsion, 26

Color shift, and reciprocity failure, *194-195;* and improper use of color film, 202
Condenser enlarger, 58
Contact sheet, for diagnosis of equipment malfunction, *114-124*
Contrast, high, 180; intentional, *163, 180-181, 184-185*
Cooke, Jerry, and radio-controlled cameras, 79
Crane, Ralph, *13,* 14
Cropping, for special effects, *186-187*
Crowds, photographing over the heads of, *66-67,* 97

Darkroom, emergency, 24-25
Darkroom errors, *122-123,* 124
Defects appearing on contact sheet: blank frames, 114; blank white areas, 114, *120-121, 122-123;* dark splotches, 122; dark streaks, *123;* diffused images, *117;* image cutoff, 114, *116, 118-119;* "lightning" stroke, *124;* multiple exposures, 114, *115;* vignetting, 114, *116*
deFrancis, Peter, 180; photograph by, *180-181*
DeLory, Peter, photograph by, *194*
Depth of field: and diffusion of backgrounds, 47, *50-51;* and diffusion of foregrounds, *48-49;* and photographing reflections, *54-55,* 177; and portraits preserving background detail, *60-61;* and selection of main picture elements, *192-193*
Developers, high-contrast, 180
Development, for high-contrast, 180, 184
Diaphragm: malfunction of, 108; test for, 108, *109*
Diffraction, for special effects, *190*
Diffused images, significance of, 117
Diffusion enlarger, 58, 59
Distance, and stop-action photography, 130
Distortions: barrel, *62,* 106, *107;* intentional, 177
Dominis, John, 31, 32; photographs by, *31, 32;* and unnoticed detail, 93
Double-pole double-throw momentary contact switch, 72, *73*
Doumani, George A., 39; photographs by, *38-39*
Drage, Derek, 168
Drake, James, 139, 152; photographs by, *138-139, 152*
Dressen, Chuck, 98
Dry environments, equipment problems in, 21-22
Dust on negatives, symptoms of, 122
Dusty environments: effects of, on camera mechanism, 21; effects of, on film, 21; effects of, on lenses, 21; photographs taken in, *cover, 28-29, 32;* protection of equipment in, *19,* 21-22, 26, 32
Dutton, Allen, photograph by, *cover*
Duze, Harvey, photograph by, *188*

Early, Dennis, 170; photograph by, *170*
Eastman Kodak Co., 158

Education in photography, 158-172; Rochester Institute of Technology, 157-172
Eisenstaedt, Alfred, 94; and photographing over crowds, 97
Electronic flash. *See* Strobe lights, electronic
Electrostatic discharge, film exposed by, 22, 24, 96, *124*
Emulsion(s), effect of physical environment on collodion, 26
Enlargers, condenser vs. diffusion, 58, 59
Eppridge, Bill, photographs by, *157-161*
Equipment care: in cold environments, *19,* 22-24, 36, 40; in dry environments, 21-22; in dusty environments, *18,* 21-22, 26, 32; in hot environments, 13-14, *19,* 96; in humid environments, 15, 17, *19;* in wet environments, *18,* 20-21, 31, 35
Equipment for special problems: bicycle-pump shutter release, 70, 72; motor-driven tripod head, 74, *75,* 76; nitrogen-filled camera housing, *76, 77;* remote control for cameras and strobe lights, *78,* 79-80; sequential switch for strobe lights, *74;* switch for combination time-strobe exposures, 72, *73;* timers for motorized cameras, 76, 77, 78
Equipment for sports photography, 132-133; helicopter, 150; motorized camera, 133, 136, 151; slit camera, 134, 140, 146; strobe lights, 129, 144
Equipment for testing cameras: at home, *104-111;* professional, *112-113*
Errors, profiting from, 92-98
Exposure(s): affected by snow-covered terrain, 23; calculation in Antarctic conditions, 39; for day-into-night effect, *196-197;* in desert, 26; very long, 90, *194-195*
Exposure meters: in cold environments, 23; effects of water on, 20, 32; selenium vs. cadmium sulfide cells, *19,* 23
Exposures, multiple, *88-89,* 101, *115;* intentional, *88-89, 176-177;* significance of, 114, 115; using masks for, *88-89*
Extension rings, for photomacrography, 86, *87*

Film: effects of cold on, 23-24, 96; effects of dust on, 21; effects of fungus on, 15; effects of heat and humidity on, 14-17, 96; effects of moth and mildew repellents on, 17; effects of water on, 20; high-contrast, 180, 184, 185; high-resolution, for testing lenses, 106; incorrectly loaded into camera, 94-95; incorrectly loaded into developing tank, 122; indoor vs. outdoor color, 202; reciprocity failure of, 195; slow film and long exposures, 90
Film-advance mechanism: manipulation of, for intentional

double exposures, 176-177; symptoms of malfunction of, 114, 115
Filters: cross-screen, 190; to enhance contrast, 90; fog-illusion, 82; as lens protectors, 21, 28, 35; polarizing, 47, 52-53; red and yellow, 47; skylight (ultraviolet), 23; split, 47, 82; and vignetting, 116
Fixer, stale, effect of, *123*
Flare: prevention of, *56-57;* use of, *190*
Focusing system, test of, 112, *113*
Fog, illusion of, 82, *83*
Foregrounds, diffusing of distracting, *48-49*
Freezing motion. *See* Stop-motion photography
Freni, Al, 147; photograph by, *147*
Friedman, Benno, 192; photographs by, *192, 193*
Fungus: effects of, on film, 14; effects of, on lens, 14; protection against, 15, 17, 30

Gaffer tape, *19,* 25
Glatzel, Erhard, 62
Gleason, Judie, 172; photograph by, *172*
Gonzales, Pancho, 93
Goodman, Robert B., 28; photographs by, *28-29*
Goro, Fritz, and camera malfunction, 102
Graininess, 176, 185; causes of, 178; intentional, *178-179*
Green-Armytage, Stephen, *202*
Groskinsky, Henry, 14; and exposure of hot lamps to precipitation, 94

Haling, George, demonstration of elimination of distracting background, *50-51*
Harrod, Denny, *161*
Haskell, Jonathan, photographs by, *165*
Hattersley, Ralph, 162
Hayes, Keith J., 97
Hayes, Mrs. Keith J., *96,* 97
Hockman, Mark, *169*
Hofer, Evelyn, and long exposures, 90; photographs by, *58-59, 91*
Hogan, Ben, 94
Hologon (lens), 15mm, 62, 63
Hot environments: effects of, on cameras, 12-13, 14; effects of, on film, 14-15, 17, 96; photographs taken in, *cover, 27, 28-29, 30, 31;* protection of equipment in, 13-15, 17, *19*
Huljack, Greg, photograph by, *165*
Humid environments: and heat, effects of, on film, 14-17; photographs taken in, *30, 31;* protection of film in, 15, 17, *19*
Hunt, Keith, photograph by, *165*

Ice, on cameras and lenses, 22-23
Image cutoff, *118-119;* intentional, *186,* 187; significance of, 118-119. *See also* Vignetting
Image intensifier tube, 64

Iooss, Walter, Jr., 133, 134, 196; photographs by, *124, 134-135, 196-197*

Jacobson, Gerald: photographs by, *84-85, 101;* and of shadows, 84
Jensen, Paul, demonstration of diffusion of distracting foreground, *48-49*
Joel, Yale, *71;* and bicycle-pump shutter release, 70, 72; and motor-driven tripod head, 74, 75, 76; photographs by, *71, 75*
Johansson, Ingemar, *136-137*
Johnson, Lyndon B., 95
Josephson, Ken, *183*

Kami (Richard Kam), *184,* 185; photographs by, *184-185*
Kauffman, Mark, *92;* and the "easy" subject, 97-98; and equipment in the desert, 96; and hole in shutter, 95; and the ignored picture, 98; and incorrectly loaded film, 94-95; and incorrectly wired strobe lights, 93-94; and photographing in crowds, 97; photographs by, *96-97, 98;* and shutter noise, 94; tales of, 92-98; and tripod substitute, 95; and uninformed subject, 97; and unnoticed background, 92-93
Keegan, Marcia, photographs by, *190, 191*
Kellerhouse, Karen, photograph by, *164*
Keshen, Cary, *161*
Kidd, Billy, *146*
Kirman, Charles, 171; photograph by, *171*
Kober, Fritz, 62
Krukowski, Dennis, photograph by, *166*

Lamb, John Graham, photograph by, *189*
Lane, Whitney L., 199; photograph by, *199*
Lansbury, Angela, 92
Lean, David, 96
Leifer, Neil: photographs by, *146, 150;* and sports photography, 132, 134, 146, 150
Lens(es): aberrations of, 106, 200; Circo-Mirrotach attachment, *68;* cleaning of, 117; effects of dirt on, 21, *117,* 190; effects of fungus on, 14; effects of heat on, 12-13; effects of high pressure on, 78; fisheye, 188; and flare, 56, 190; Hologon, 15mm, 62-63; ice on, 23; inferior, for special effects, 200; long focal length, 47, 48, 50, 139, 140, 152, 192; manipulated, 190-191; "periscope," 47, *68;* resolution test for, 104-105; reversal of, for photomacrography, *86, 87;* split-field, 46, 60-61; and vignetting, 114, *116;* wide-angle, 47, 149, 152, 177, 193, 196; zoom, 132, 154. *See also* Equipment care
Lens shade, *18;* and vignetting, 116
Leonian, Phillip, photograph by, *127*
LIFE Photo Lab: equipment

inventory of, 80; special equipment of, 72-81
Light bulbs, exposure of, to precipitation, 94
Light leak, symptoms of, 96, 114, *120-121*
"Lightning" stroke in print, 22, 24, 96, *124*
Low-light-level camera system, 47, 64, 65; applications of, 64

McCombe, Leonard, 35; photograph by, *34-35*
McLain, Denny, 153
McQuade, John, photograph by, *164*
Margaret, Princess, 95
Masks, for multiple exposures, *88,* 89
Mercouri, Melina, 97
Mildew. *See* Fungus
Miller, Mike, *113*
Mirrors: photographs of objects in, *54-55;* in right-angle lens attachment, *68*
Mistakes, profiting from, 92-98
Mold. *See* Fungus
Mood of picture: and elimination of detail, *58-59,* 178, *198-199;* and optical system of enlarger, *58-59*
Moore, Charles, 26; photograph by, *27*
Moore, David, 195; photograph by, *194-195*
Morse, Gary, *160*
Morse, Ralph: and direct-wire remote control, 80, 81; and lenses exposed to high pressures, 78; and multiple exposures using masks, 88-89; photographs by, *81, 89;* and timers to control cameras, 77, *78*
Motion, photography of, *73, 75,* 127, 128-133, *134-154, 170-171;* by blurring, *127,* 129, 131-132, 170-171; and camera angle, 130; and panning, 130-131; and peak action, 129-130; in sequences, 129, 131, 136; with slit camera, 134, 140, 146; special equipment for, 72, *73, 74, 75,* 76; and sports, 132-133; *134-154*
Motion analyzer, *113*
Motor-driven tripod head, 74, 75, 76
Motorized cameras, 76, 77-81, 94, 99, 106, 111, 133, 136, 140, 146, 151; and electrostatic discharges, 124; and sequences of photographs, 131, 136
Multiple exposures. *See* Exposures, multiple

National Geographic, The, magazine, 103
Neckstraps: effect of perspiration on, 20; metal, 20
Nitrogen-filled camera housing, 76
Nkrumah, Kwame, 93-94
Nunley, Robert R., 40; photograph by, *40-41*

Olson, John, 36; photograph by, *36-37*
Osborne, Walter D., 154;

photograph by, *154*
O'Toole, Peter, 96

Panning, 127, 130-131, 148; and motor-driven tripod head, 74, *75,* 76, *147, 148-149*
Patterson, Floyd, *136-137*
Peak action, 129-130, 142
Pelham, Lynn, photograph by, *142*
People, elimination of, when obstructing subject, 90, *91*
Perspective, distortion of, 177, *188-189*
Perspiration, effect of, on equipment, 20
Phosphorescent tape, for testing shutter synchronization, 110, 111
Photography, education in, 158-172; Rochester Institute of Technology, *157-172*
Photomacrography, with reversed lens, *86, 87*
Polarized light, from reflections, 52
Polarizing filter, to eliminate reflections, 47, *52-53*
Prefocusing, 133, 147
Pressure plate: and excessive film tension, 114; and image sharpness, 104
Processing errors, *122-123*

Races, radio-controlled cameras to photograph, 79
Range finder, and image sharpness, 104
Raymond, Lilo, 176; photograph by, *176-177*
Reciprocity failure, 195; for special effects, *194-195*
Reflections: elimination of, *52-53;* photographing objects and their reflections, *54-55,* 168, *169,* 177
Relays, for remote control of motorized cameras, *80*
Remote control: direct-wire, for cameras, 79, *80;* radio, for cameras, *78,* 79, 80; radio, for strobe lights, 78
Rentmeester, Co, *20,* 32; and camera malfunction, 102; photograph by, *33*
Repairs, camera, emergency, 24-25
Resolving power, of lenses, 104-105
Rochester Institute of Technology: Biomedical Photography, *159;* facilities of, *160-161;* Photographic Science and Instrumentation, 159; School of Photographic Arts and Sciences, *157-172;* School of Printing, 160
Rocket launchings, special equipment to photograph, *76,* 77
Rougier, Michael, 30; photograph by, *30*
Rules, creative breaking of, *175-202*

Salt water: effects of, on equipment, 20; emergency treatment for immersion of camera in, 20. *See also* Wet environments
Sandwiching, 177
Sapp, Theron, *134-135*
Scheller, Donald, 168; photograph by, *168*
Scherschel, Joe, 72; and radio

control of cameras, 79; photograph by, *73;* and special equipment to photograph motion, 72, 74
Schneider, Al, *80;* description of equipment for special problems of LIFE photographers, 72-80
Schneider, Romy, 97
Schulthess, Emil, 42; photograph by, *42*
Schweikardt, Eric, photograph by, 143
Sealab I, *77;* photographic coverage of, 78
Sequence photographs, 131, 136, *138-139*
Shadows, photography of, *84-85, 182-183*
Shakbut bin Sultan, 13
Shoemaker, William S., 159
Shull, Henry A., *200-201*
Shutter(s): corrosion of, 32; effect of cold environments on, 22, 36; holes in, 96; malfunctions of, 108, *118-119;* noise of, 94; speeds of, and photography of motion, 72, 74, 129-130, 131, 136; synchronization of, with strobe lights, 110-111, 112, 118, 119; tests for, 108-109, 113
Silica gel, 17, *19,* 30
Silk, George: photographs by, *136-137, 140-141, 151, 152;* and sports photography, 136, 140, 151, 152
Single-lens reflex, and photographing over heads of crowds, 66-67
Slit camera, 134, 140, 146; photographs taken with, *140-141, 146*
Smith, Robert, and sports photography, 132-133
Snead, Sam, 94
Snow, effects of, on exposure, 23
Snyder, Joel: and fog-illusion filter, 82; photograph by, *83*
Southern Illinois University, 158
Special effects by breaking rules, *175-202;* backlighting, *196-197, 198-199;* blending of colors, *200-201;* blur from greased filter, 190, *191;* blur from inferior lens, *200-201;* blur by selective focus, *192, 193;* color shift, *194-195,* 202; cropping, *186-187;* day into night, *196-197;* diffraction of light, *190;* elimination of detail, *175, 178-179, 180-181, 198-199;* fog effect, 82, *83;* graininess, 176, *178-179;* high contrast, *180-181, 184-185;* multiple exposures, 88-89, *176-177;* perspective distortion, 177, *188-189;* sandwiching, 177; shadows, *84-85, 182-183;* silhouettes, *175, 178-179, 198-199;* "stars," *190;* unusual angle, *175. See also* Equipment for special problems; Motion, photography of
Split-field lens, 60-61
Sports photography, 132-133, *134-154*
"Stars," *190;* filter to create, 190
Stop-action photography, 128-131, *134-135, 136-137, 138-139, 142-143, 144-145, 147, 148-149, 152;* and camera angle, 130, 152; and

distance, 130; and panning, 130-131, 148; and peak action, 129-130, 142; and sequence photographs, 131, 136
Streaks, on contact print, *123;* significance of, 123
Strobe lights, electronic: double-pole double-throw momentary contact switch for, 72, *73,* 74; incorrect wiring for, 93-94; remote radio control for, *78;* sequential rotary switches for, *74;* and stop-action photography, 129, 144; synchronization of, with shutter, 110-111, 112, 118, 119
Sund, Harald, 178; photographs by, *175, 178-179*
Switches: double-pole double-throw momentary contact switch, 72, *73,* 74; sequential rotary switch, *74*
Synchronization of shutter with strobe, 110-111, 112; symptoms of malfunction of, 118, *119*

Synchro-Tester, *112*
Szczygielski, Anthony, 187; photographs by, *186, 187*

Temperature, effect of, on film. *See* Cold environments; Hot environments
Tension on film, symptoms of excess, *114*
Test(s): focusing system, 112, *113;* lens diaphragm, 108, *109;* lens resolution, 104-106, *107;* shutter speed, 108, *109, 113;* synchronization of shutter with strobe lights, *110-111, 112*
Test charts for lenses, *105, 107*
Thall, Garry, 169; photograph by, *169*
Thompson, Ed, 92
Timers for motorized cameras, 76, *77,* 78; cost of, 77
Triolo, Tony, photograph by, *73*
Tripod: motor-driven head for, 74, *75,* 76; substitutes for, 95

Trouble-shooting cameras, 104-124. *See also* Defects appearing on contact sheet
Twin-lens reflex, and photographing over heads of crowds, 66

Ultraviolet light, effect on color rendition of film, 23, 39
Ultrawide (camera), 62
Umbrella: in hot environments, 96; in wet environments, 20

Video Color Negative Analyzer, 160, *161*
Vignetting, *116;* significance of, 114, 116
Viki, *96-97,* 98

Waist-level viewer, 66, *67*
Walch, Bob, 45; demonstration of elimination of reflections, *52-53*
Walker, Hank, *24*
Washburn, Bradford,

photograph by, *11*
Waterproof camera housings, 20-21
Wayman, Stan, 15; photograph by, *16*
Weather. *See* Cold environments; Dry environments; Hot environments; Humid environments; Wet environments
Weston, Edward, 172
Wet environments: effects of, on cameras and film, 20-21, 32; effects of, on exposure meters, 20, 32; photographs taken in, *30-31, 32-33;* protection of equipment from, *18,* 20-21, 31, 35. *See also* Humid environments
White, Minor, photograph by, *cover*
Wide-angle pictures, elimination of barrel distortion in, *62-63*
Wills, Maury, *138-139*
Wilson, Tom, 162

Zimmerman, John, 144; photograph by, *144-145*